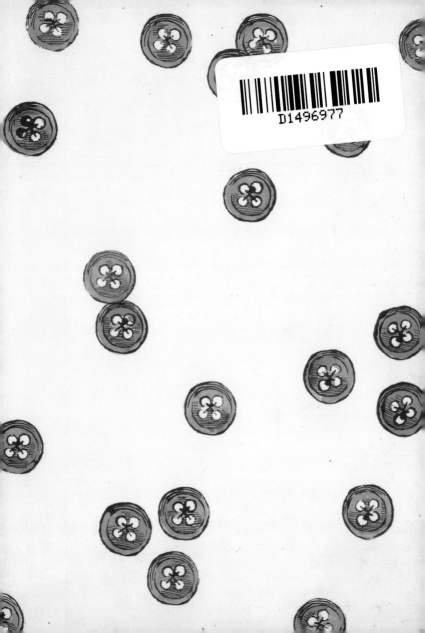

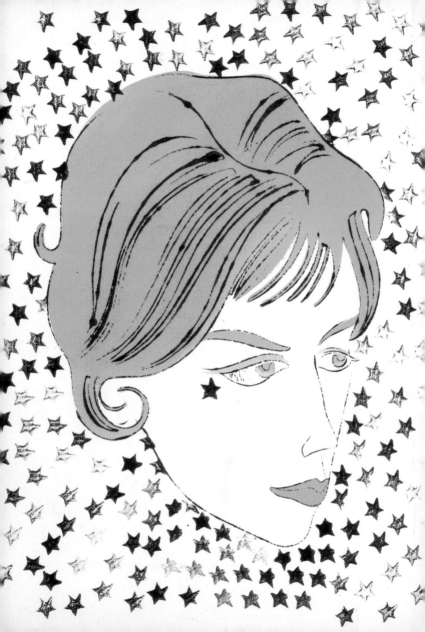

fashion

foreword by Simon Doonan

Andy Warhol

LEARNING RESOURCES
CENTRE

Havering College
of Further and Higher Education

Thames & Hudson

First published in the United Kingdom in 2004
by Thames & Hudson Ltd,
181A High Holborn, London WC1V 7QX

www.thamesandhudson.com

© 2004 by The Andy Warhol Foundation
for the Visual Arts . Foreword copyright © 2004
by Simon Doonan

Reprinted 2005

In association with The Andy Warhol Foundation
for the Visual Arts

Artwork by Andy Warhol

British Library Cataloguing-in-Publication Data
A catalogue record for this book is available from
the British Library

ISBN-13: 978-0-500-28492-6
ISBN-10: 0-500-28492-X

Printed and bound in China

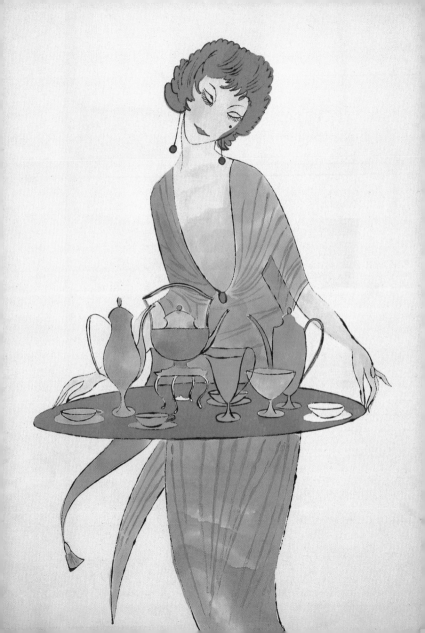

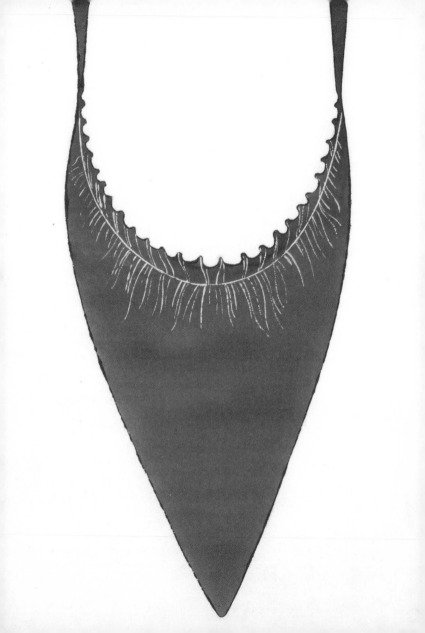

Andy Warhol was born Andrew Warhola on August 6, 1928. Born to Slovak immigrants, he was reared in a working class suburb of Pittsburgh. From an early age, Warhol showed an interest in photography and drawing, attending free classes at Carnegie Institute. The only member of his family to attend college, he entered the Carnegie Institute of Technology (now Carnegie Mellon University) in 1945, where he majored in pictorial design.

Upon graduation, Warhol moved to New York to be in the epicenter of art, publishing, and fashion. Making the obligatory rounds withother neophyte illustrators, he quickly found steady employment as a commercial artist working as an illustrator for several magazines, including *Glamour, Vogue, Harper's Bazaar,* and the *New Yorker.* He also did advertising and window displays for retail stores such as Bonwit Teller and I. Miller. Prophetically, his first assignment was for *Glamour* magazine for an article titled "Success Is a Job in New York."

Throughout the fifties, Warhol enjoyed a successful career, winning several commendations from the Art Director's Club and the American Institute of Graphic Arts. From his whimsical line drawings of cats to sleek renderings of ladies' shoes, Warhol's work became a hit in the fashion publishing world. Warhol sketched hundreds of drawings of shoes, handbags, jewelry, and gloves—some of which you will find in this book—and illustrated dozens of articles pertaining to issues of the day. During this heady period of constant commissions, he dropped the letter "a" from his Czech-sounding last name, shortening it to "Warhol."

It was during this period that Warhol had his first solo exhibition at the Hugo Gallery, exhibiting "Fifteen Drawings Based on the Writings of Truman Capote." In 1953, Warhol produced the first of several illustrated books, *A Is an Alphabet* and *Love Is a Pink Cake,* which he gave to his clients and associates. Three years later, he participated in his first group show, exhibited at The Museum of Modern Art. With a burgeoning career as an illustrator, he formed Andy Warhol Enterprises in 1957, which lay the groundwork for his future empire and meteoric rise to superstardom.

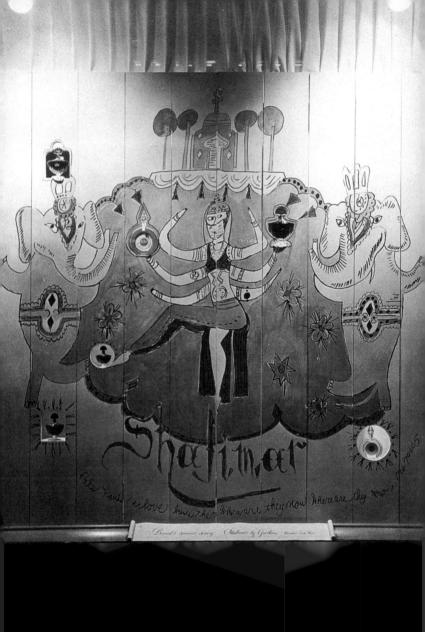

Andy loved flowers. And ladies' shoes. And beauty and shopping and drag queens and Russell Wright china and Florine Stettheimer and Carmen Miranda and gossiping on the phone and American culture and Liz and Marilyn and cookie jars and flirty boys and naughty girls.

When Andy was working as an illustrator in the 1950s, the New York art world was *très* butch—think Jackson Pollock—and the hairy, sweaty artists all hung out at the Cedar Tavern on University Place, where even among the gay patrons a boozy, angst-ridden hetero grumpiness prevailed. They recoiled from Andy the window dresser, the commercial artist, the fairy-about-town. Andy was listed under "Fashion" in a little book of the period entitled *A Thousand New York Names and Where to Drop Them*, and he was *proud* of it! An amiable chap, Andy gingerly asked his early mentor, the filmmaker/agent Emile De Antonio, why the Cedar brutes were cutting him dead. "You're too swish," said De Antonio, "and that upsets them."

Andy's conversations with De Antonio, as recorded in his 1960s memoir *Popism*, reveal the critical role Andy's commitment to his commercial work—and his swishiness—played in the development of what was to become the most notorious and well-recognized art of the 20th century. "You're a commercial artist," counseled De Antonio, "which really bugs them because when *they* do commercial art—windows and other jobs I find them—they do it just 'to survive.' They won't even use their real names whereas *you've* won *prizes!* You're *famous* for it!" While Jasper Johns and Robert Rauschenberg designed window displays under the pseudonym "Matson-Jones," Andy proudly signed his Bonwit Teller windows. (Andy's were better.) He embraced commercial art with verve, passion, and a distinctly gay sensibility. The result? The playful and astoundingly chic illustrations collected in this book, which subsequently led to the explosive Pop Art we all know and love.

But Andy was much more than just a Judy Garland–adoring invert: He was a thinker, a curious and intelligent artist whose original and sophisticated gaze surveyed the world through a prism of irony and camp. From his kooky vantage point on the margins of society, he saw

life as a stylish pastiche, full of possibilities. "All department stores will become museums," he declared, "and all museums will become department stores." He was the amused and amusing optimist whose genius changed the way we think about art.

As Andy saw it, there was nothing wrong with being a commercial artist, ". . . and as for the 'swish' thing, I'd always had fun with that." Fun was important to Andy, and it radiates from his illustrations, no matter how prosaic the product. Business suits, lipsticks, insanely pointy shoes, longline girdles, floral hats, pearls, perfume, brocade boots—the Warhol illustrations epitomize sweet post-war optimism, abundance, and *fun!* Though Andy's subsequent wealth and his iconic status irked his less poufy contemporaries, it was his ability to have fun that really made them puce with envy. And he never lost it: The bemused insouciance of these highly influential and much-copied illustrations carried through into his later artwork, even when he was silk-screening electric chairs and filming high-strung exhibitionist junkie drag queens.

The moral of the story? Trolls are scary, but everyone loves a fairy.

— Simon Doonan

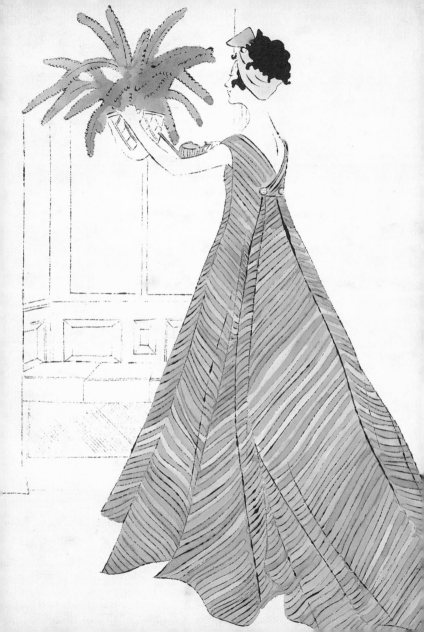

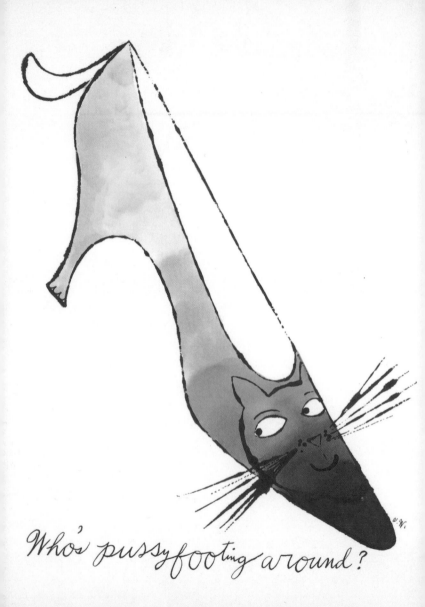

Who's pussyfooting around?

I had a job one summer in a department store looking through *Vogue*s and *Harper's Bazaar*s and European fashion magazines for a wonderful man named Mr. Vollmer. I got something like fifty cents an hour and my job was to look for "ideas." I don't remember ever finding or getting one. Mr. Vollmer was an idol to me because he came from New York and that seemed so exciting.

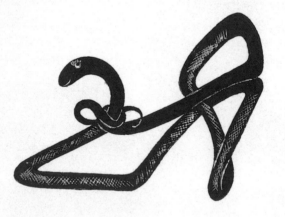

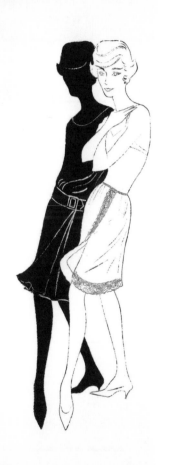
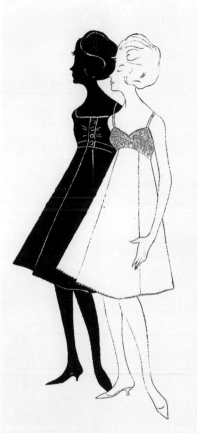

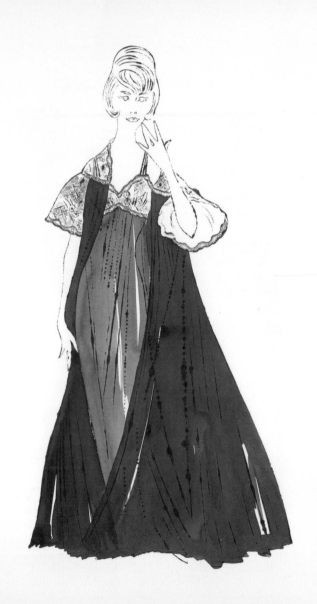

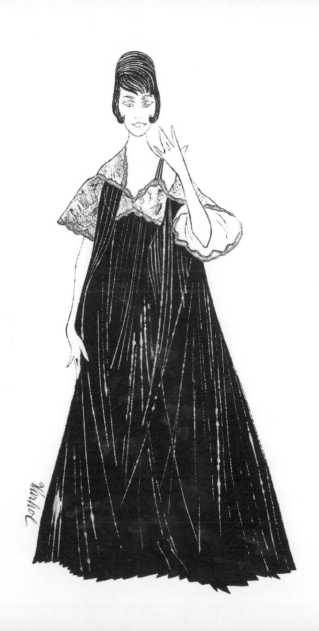

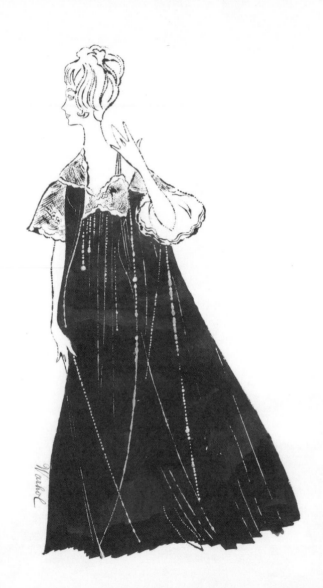

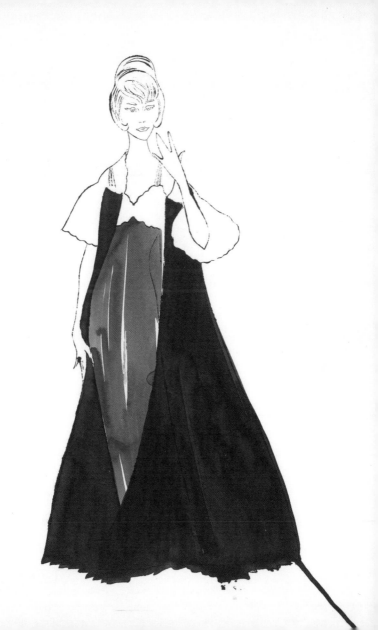

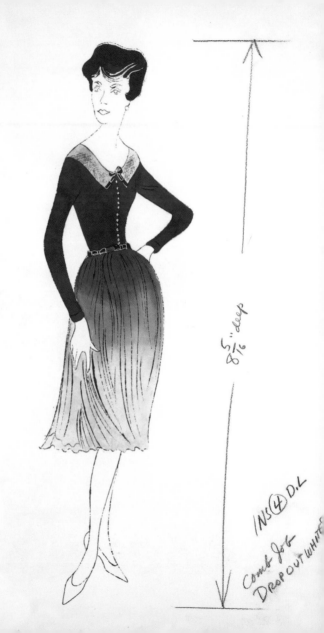

5/16" deep

1NS④ D.L
Comb Job
DROPOUTWHITE

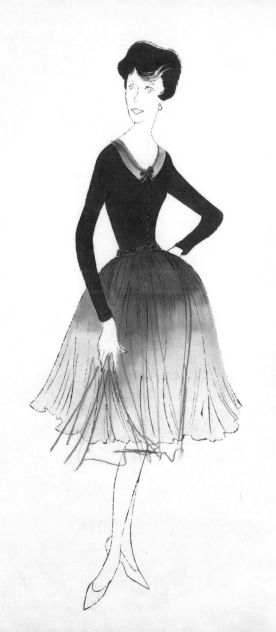

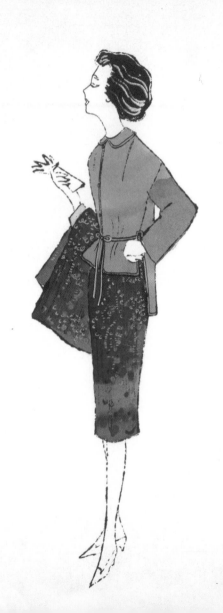

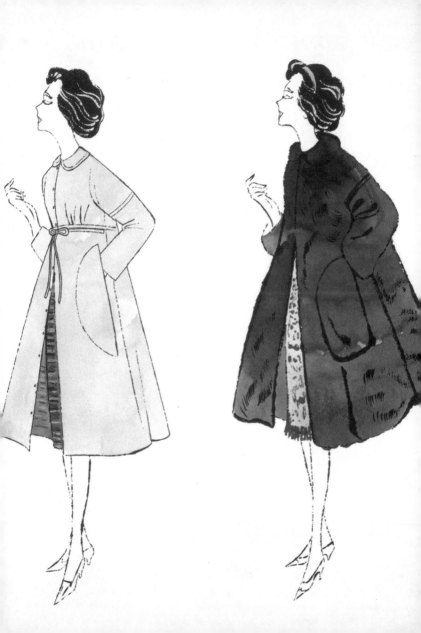

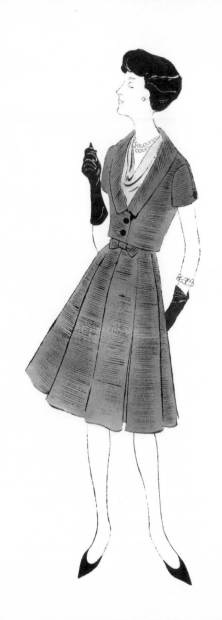

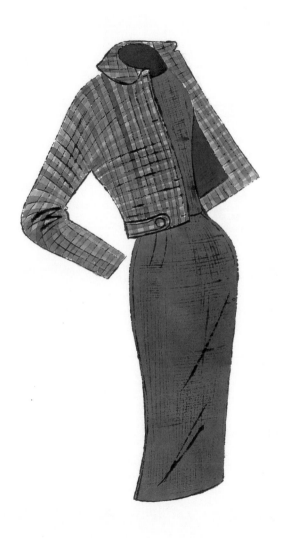

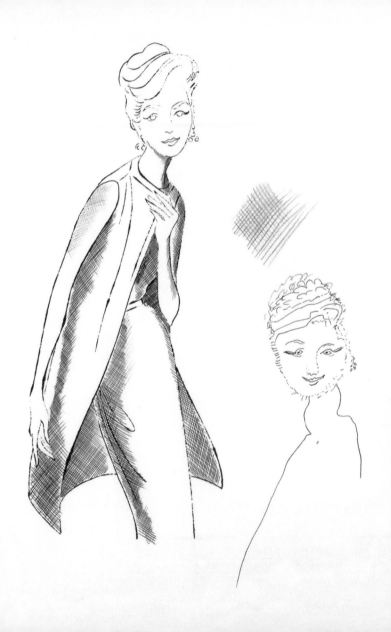

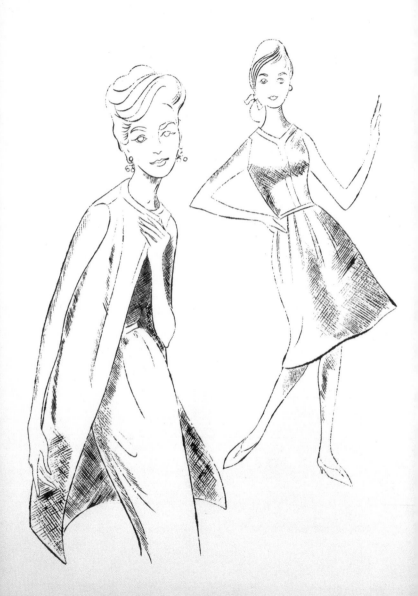

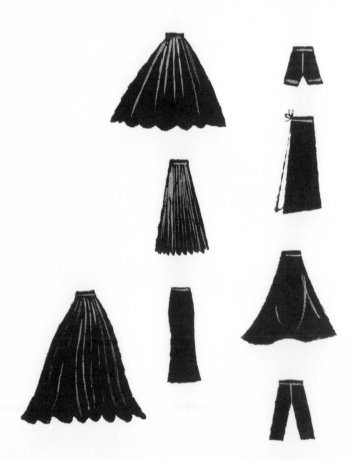

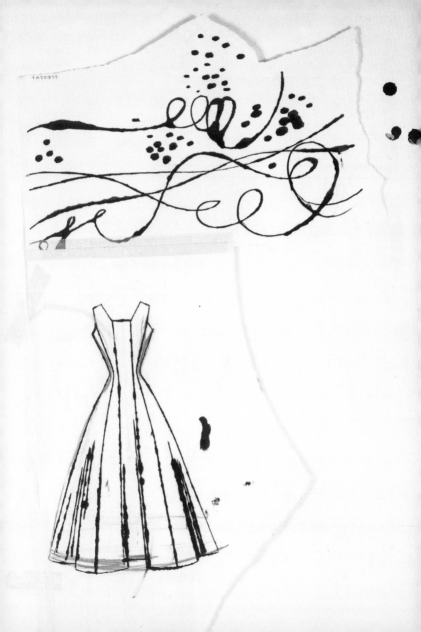

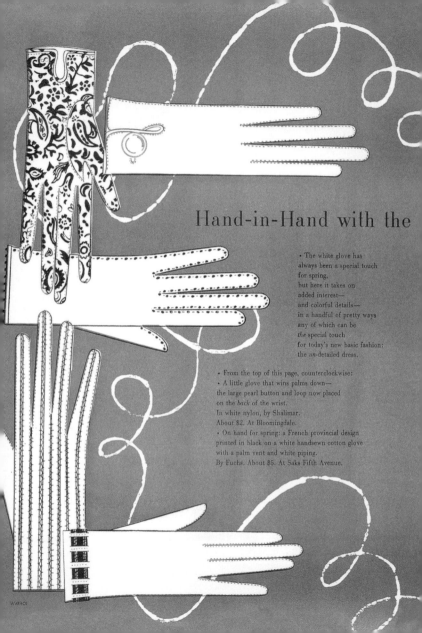

Hand-in-Hand with the

• The white glove has
always been a special touch
for spring,
but here it takes on
added interest—
and colorful details—
in a handful of pretty ways
any of which can be
the special touch
for today's new basic fashion:
the *un*-detailed dress.

• From the top of this page, counterclockwise:
• A little glove that wins palms down—
the large pearl button and loop now placed
on the *back* of the wrist.
In white nylon, by Shalimar.
About $2. At Bloomingdale.
• On hand for spring: a French provincial design
printed in black on a white handsewn cotton glove
with a palm vent and white piping.
By Fuchs. About $5. At Saks Fifth Avenue.

WARHOL

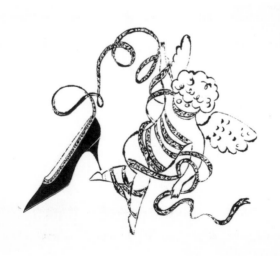

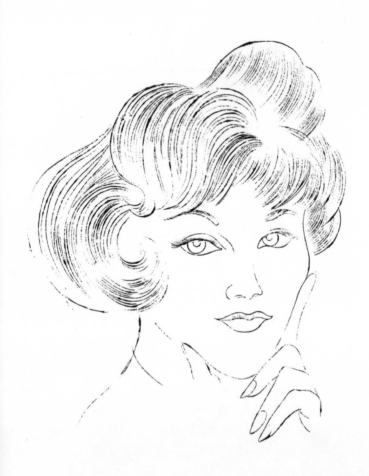

Here Lies the Heart

a tale of my life

by

Mercedes de Acosta

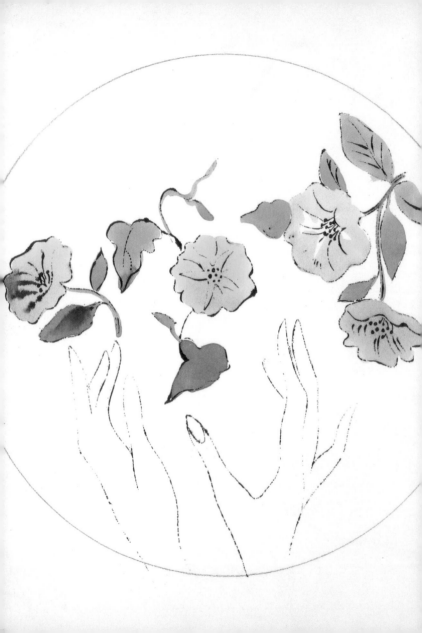

When I was eighteen a friend stuffed me in a Kroger's shopping bag and took me to New York. . . . I kept living with roommates thinking we could become good friends and share problems, but I'd always find out that they were just interested in another person sharing the rent. At one point I lived with seventeen different people in a basement apartment on 103rd Street. . . . I'd be making the rounds looking for jobs all day, and then be home drawing them at night. That was my life in the '50s: greeting cards and watercolors and now and then a coffeehouse poetry reading.

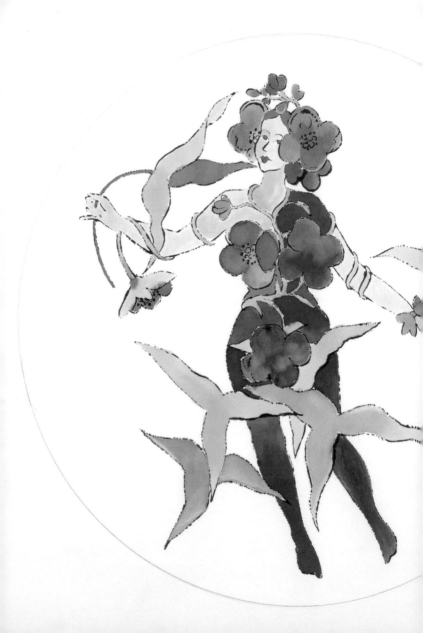

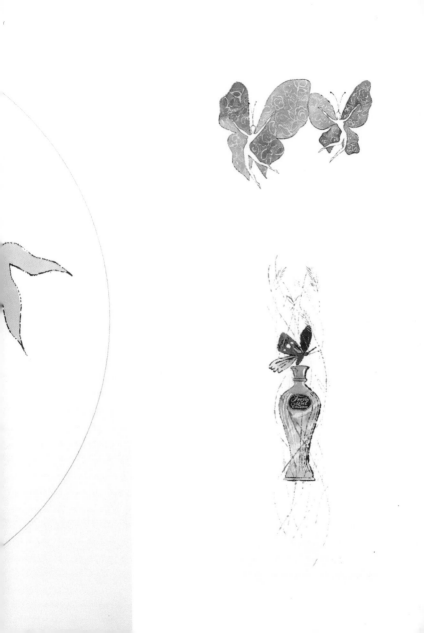

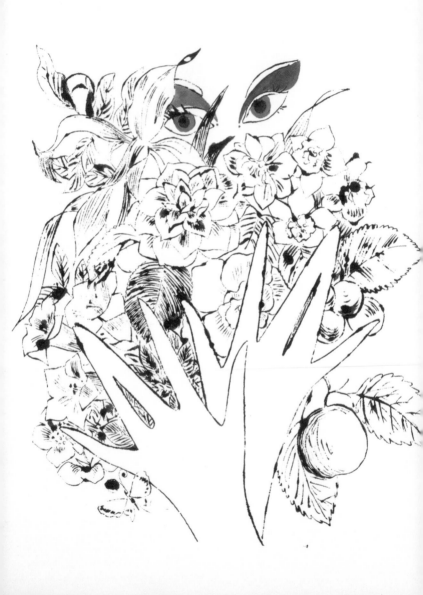

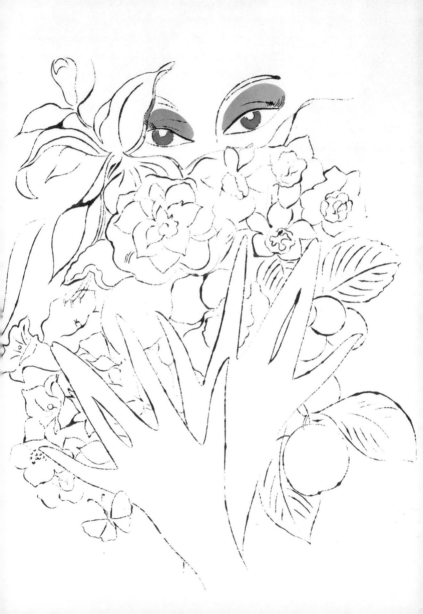

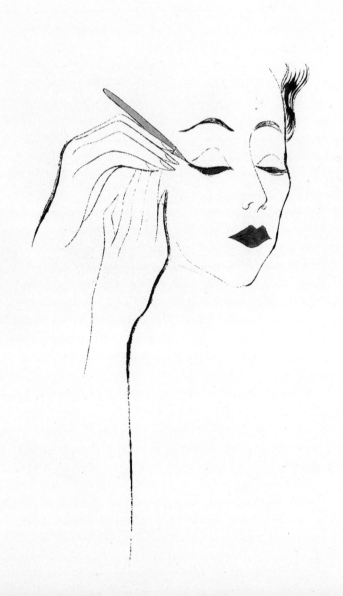

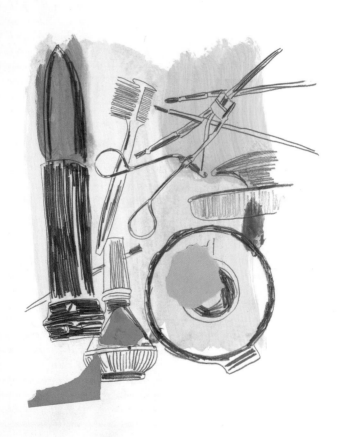

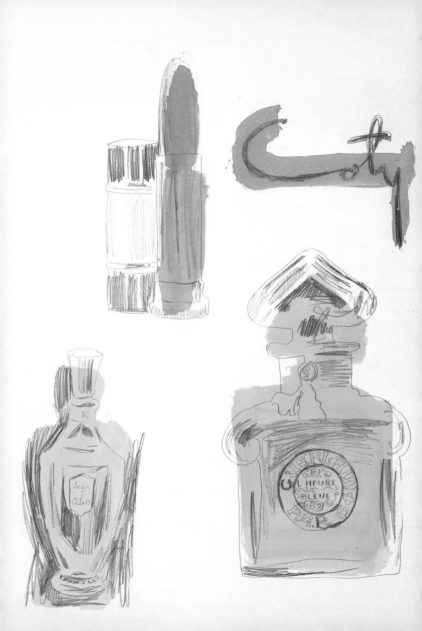

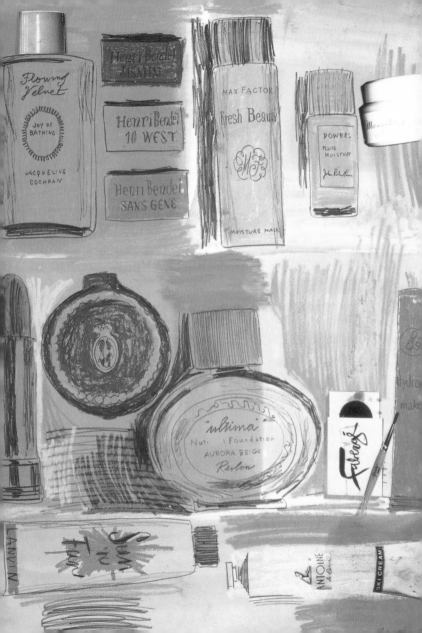

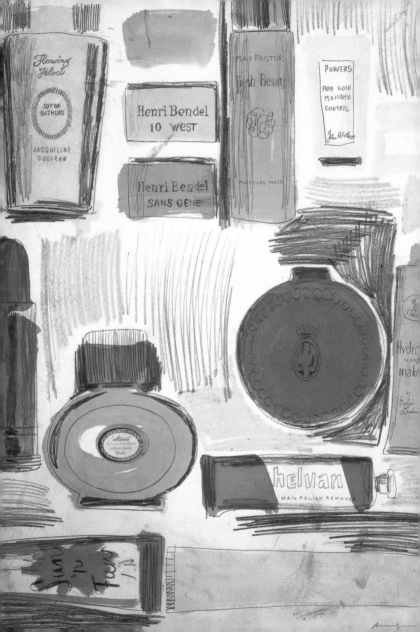

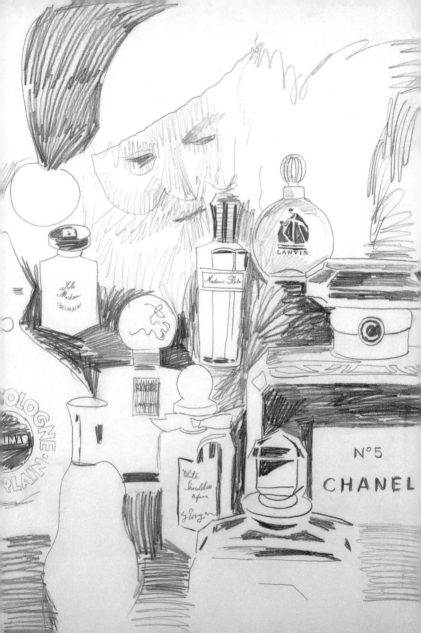

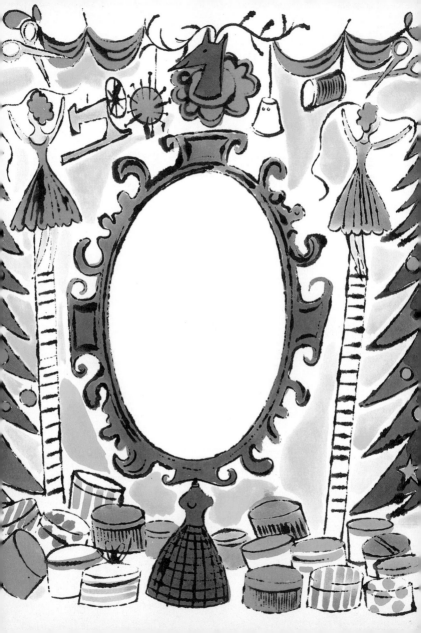

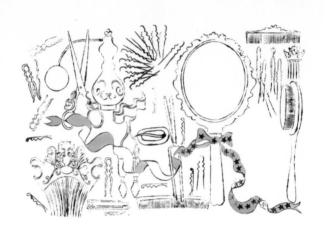

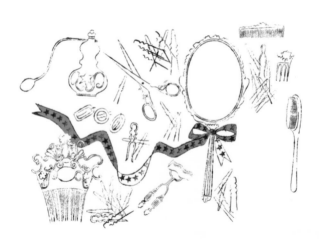

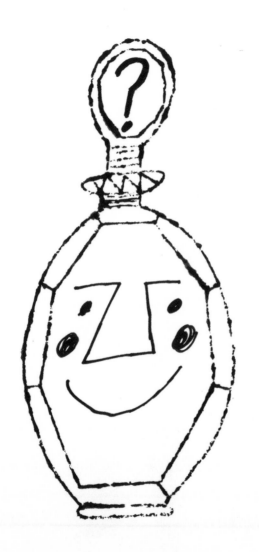

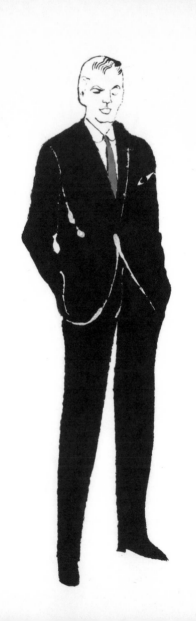

The things I remember most about those days, aside from the long hours I spent working, are the cockroaches. Every apartment I ever stayed in was loaded with them. I'll never forget the humiliation of bringing my portfolio up to Carmel Snow's office at *Harper's Bazaar* and unzipping it only to have a roach crawl out and down the leg of the table. She felt so sorry for me that she gave me a job.

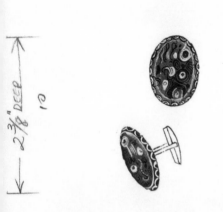

↑
2⅜" DEEP
10
↓

SIL
COMB. JOB.
DROP OUT WHITES

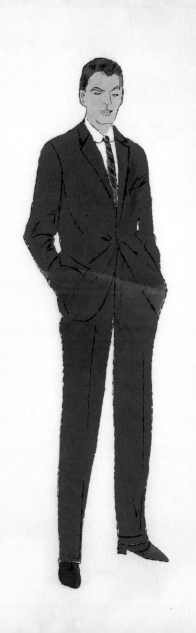

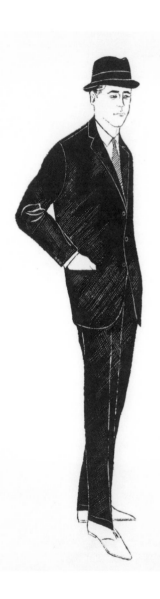

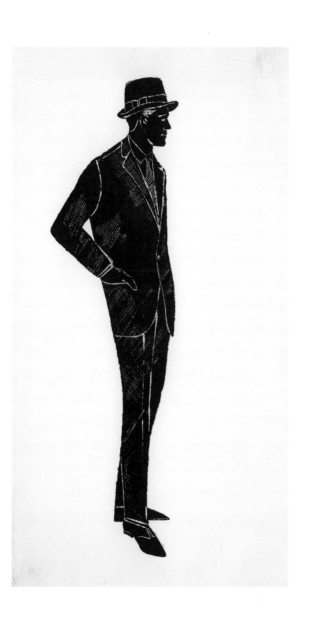

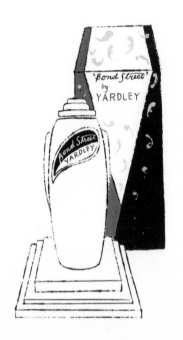

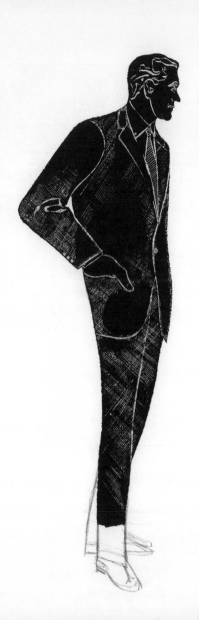

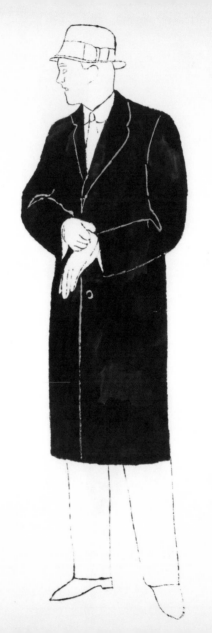

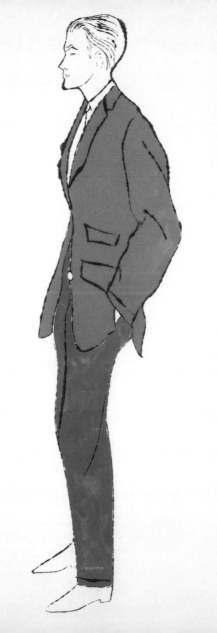

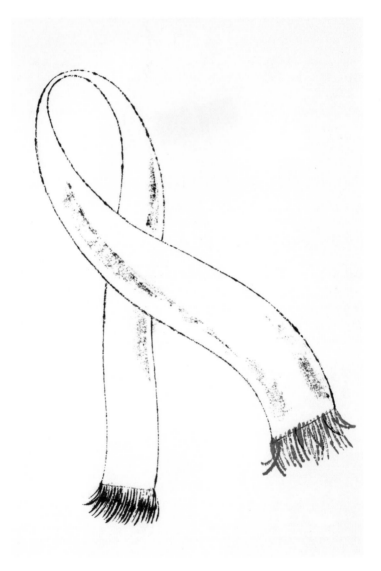

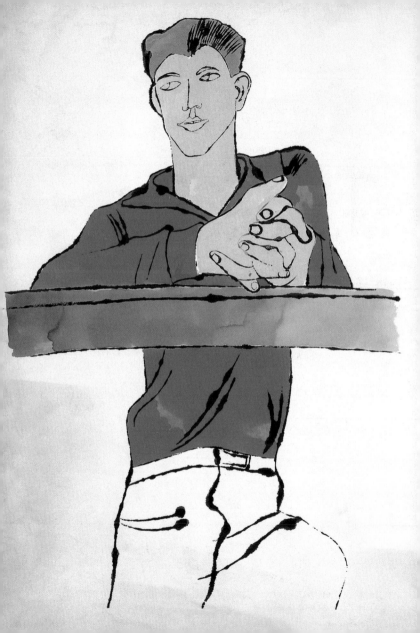

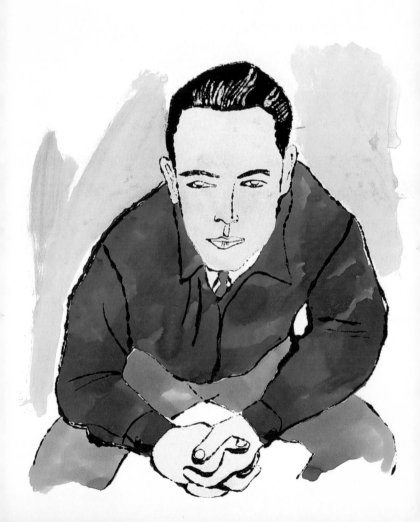

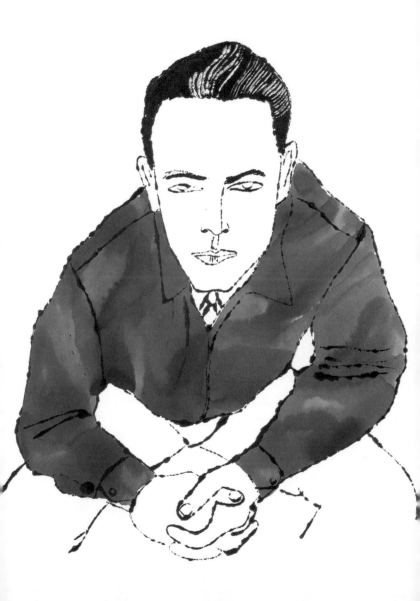

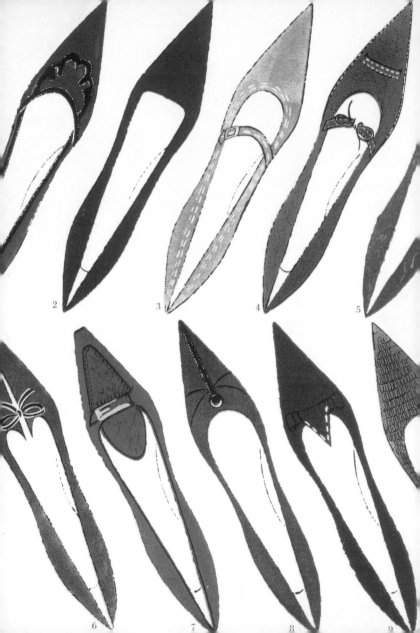

When I used to do shoe drawings
for the magazines, I would get a
certain amount for each shoe, so
then I would count up my shoes
to figure out how much I was going
to get. I lived by the number of
shoe drawings—when I counted them
I knew how much money I had.

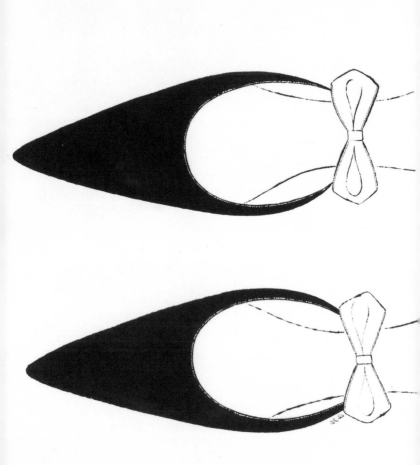

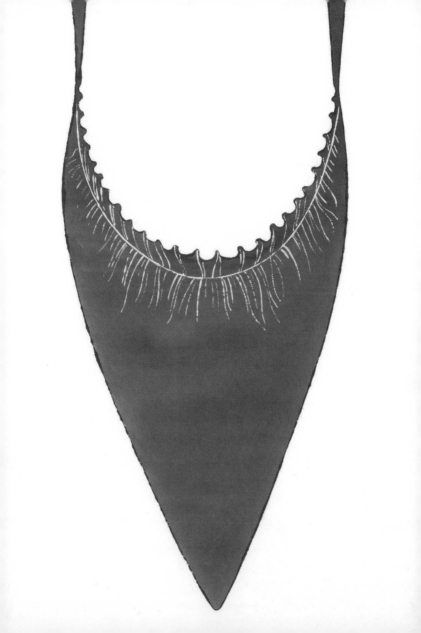

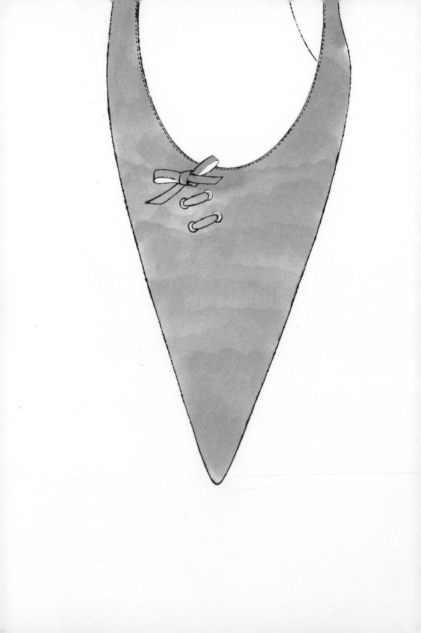

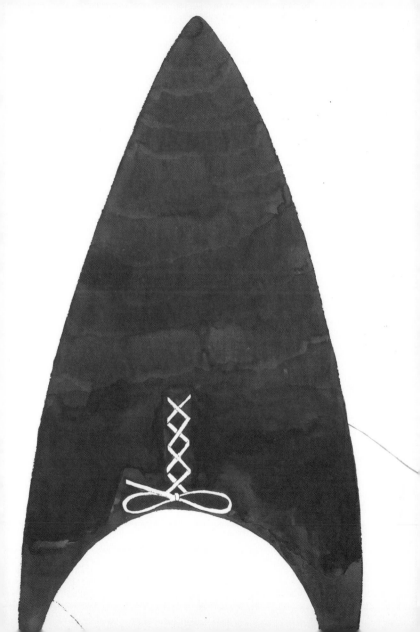

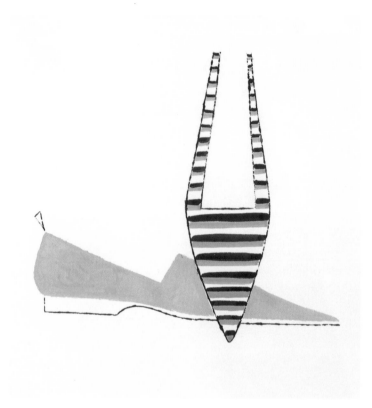

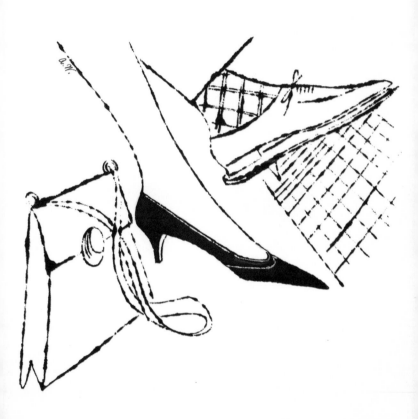

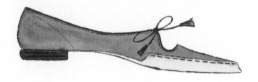

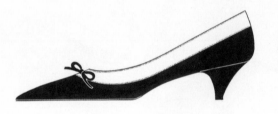

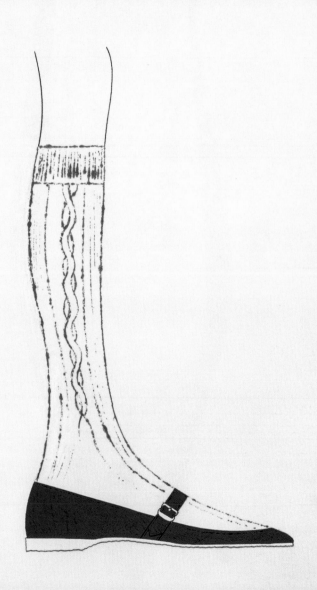

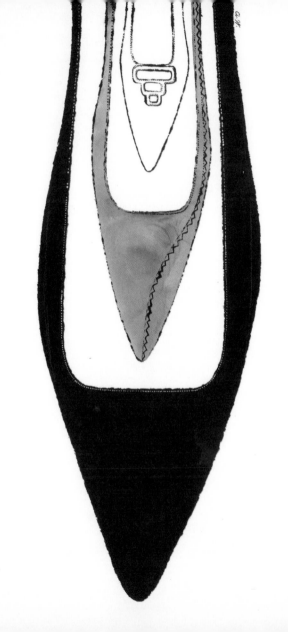

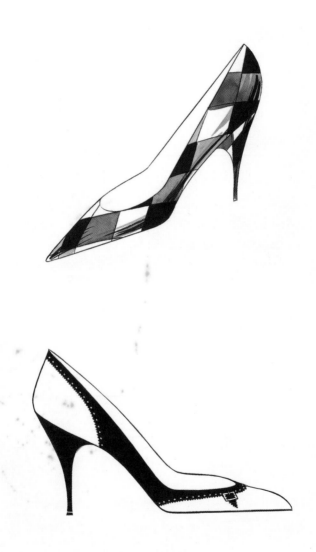

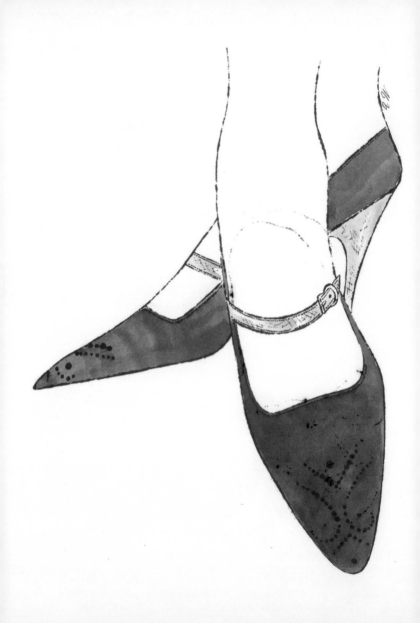

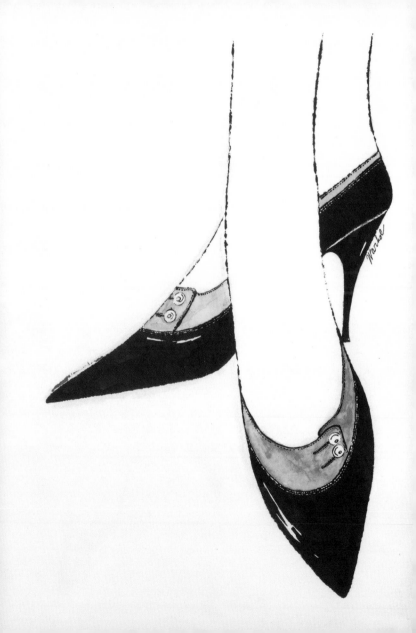

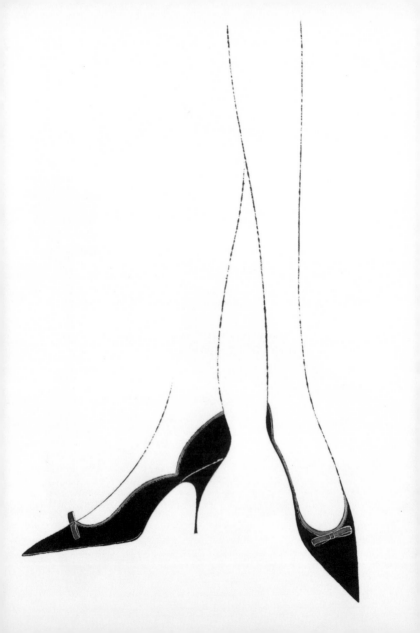

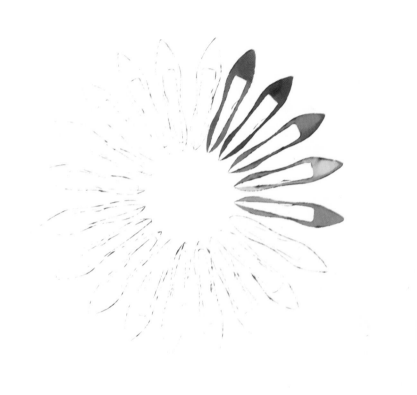

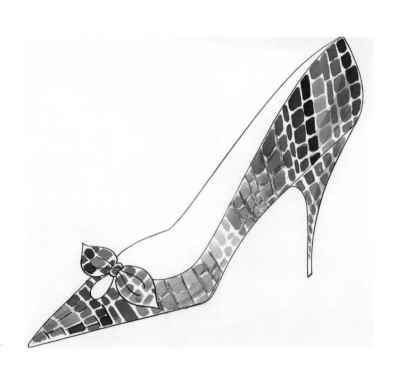

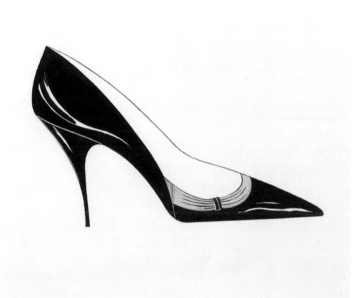

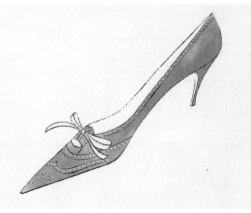

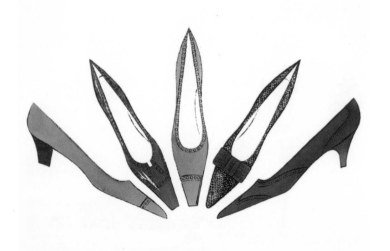

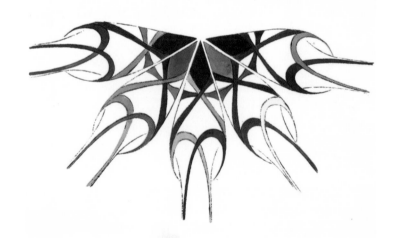

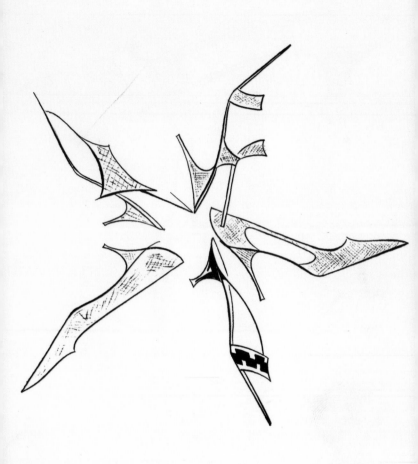

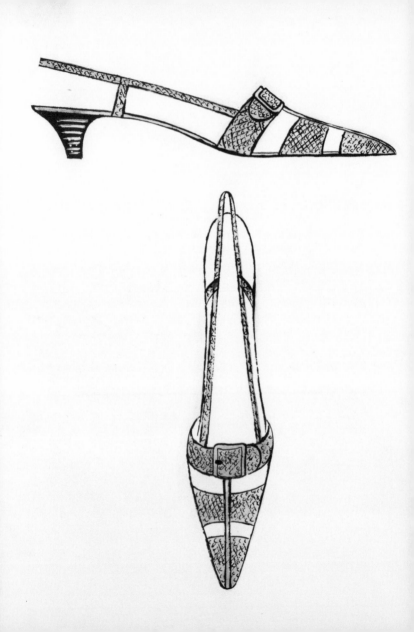

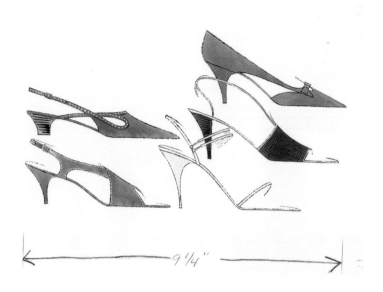

9¼"

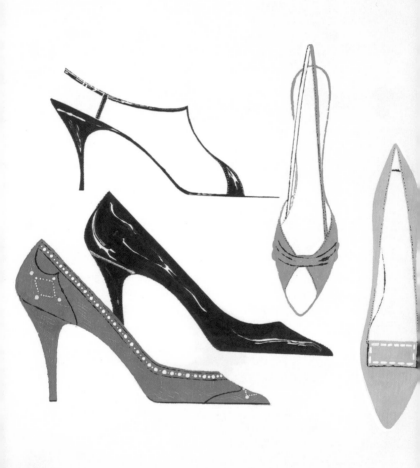

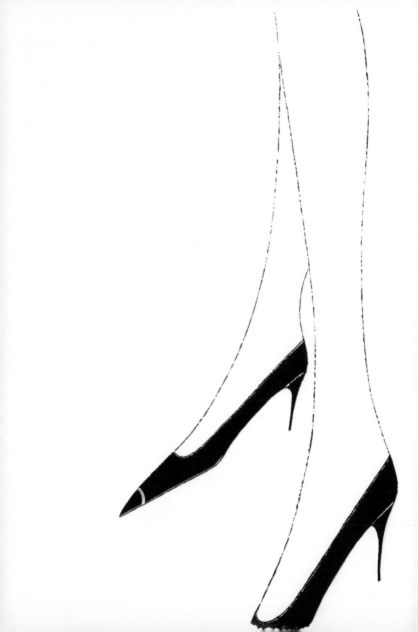

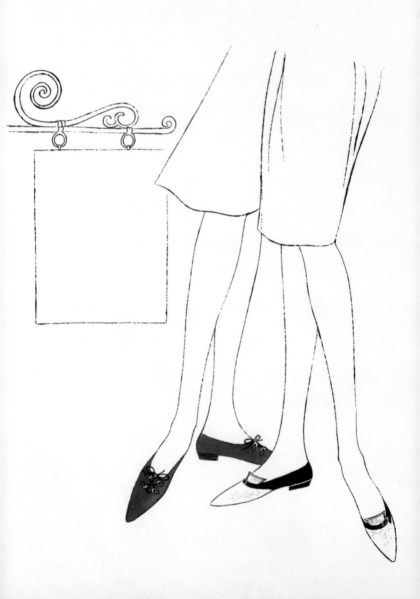

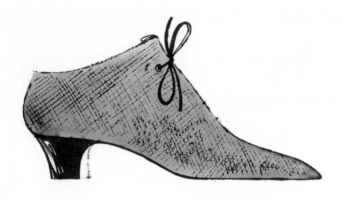

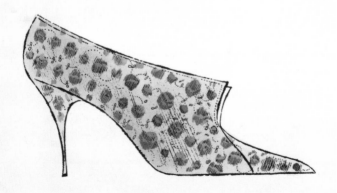

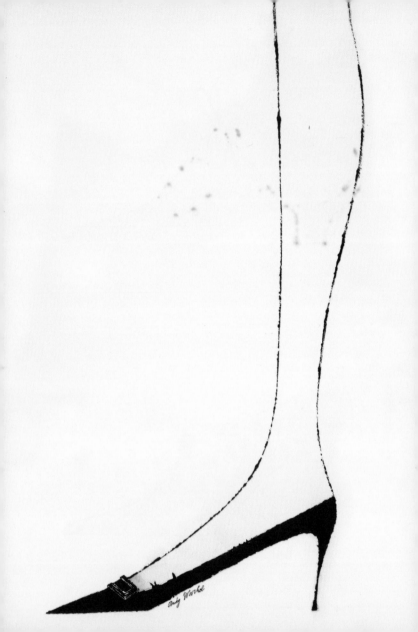

Andy Warhol

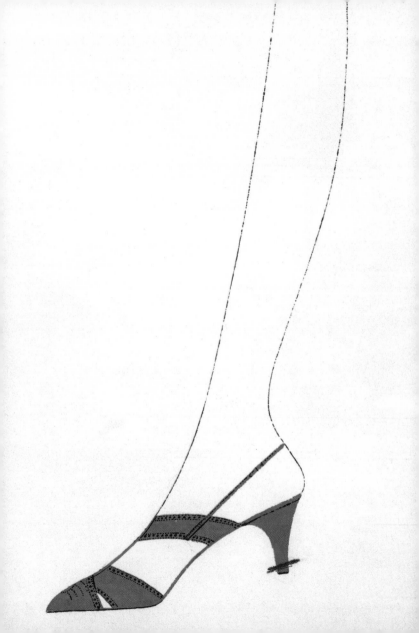

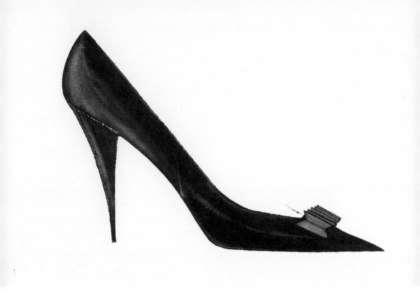

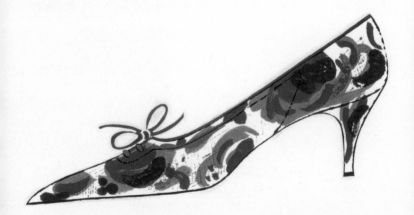

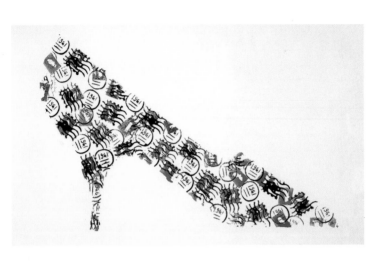

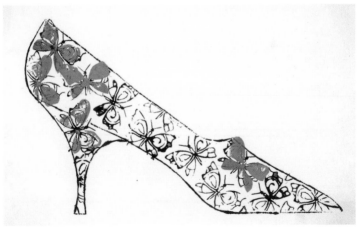

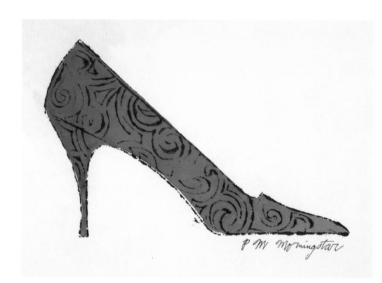

P M Morningstar

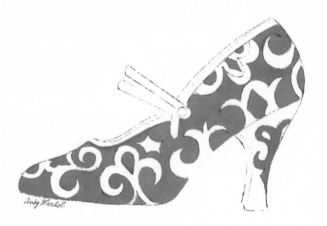

Andy Warhol

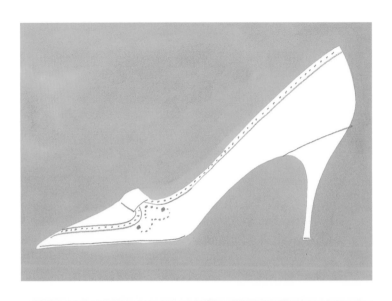

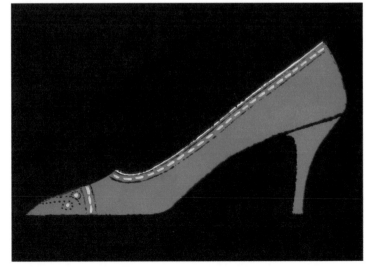

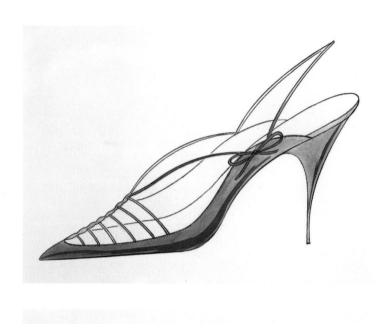

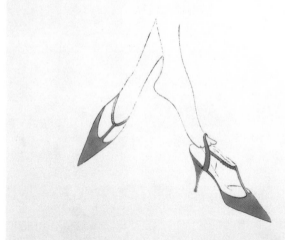

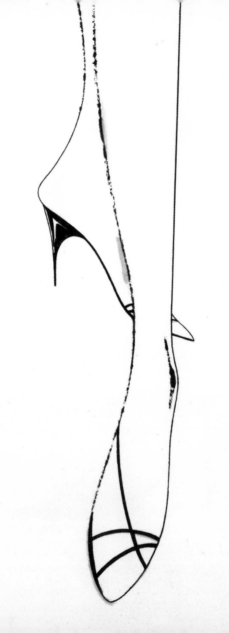

to shoe or not to shoe

to shoe or not to shoe

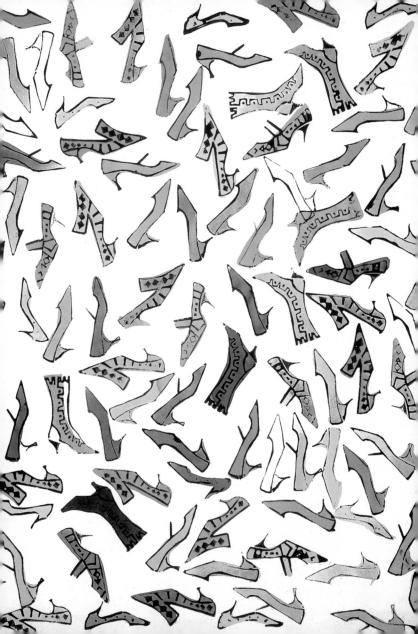

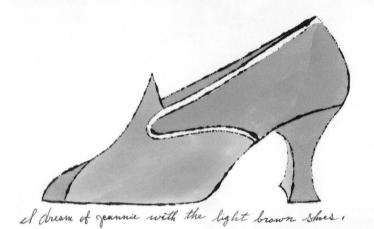

I dream of jeannie with the light brown shoes.

Andy Warhol

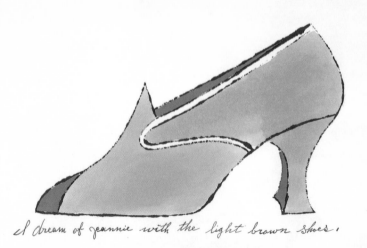

I dream of jeannie with the light brown shoes.

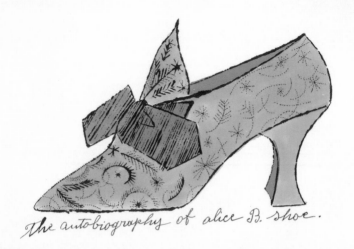

The autobiography of alice B. shoe.

In her sweet little alice blue shoes—

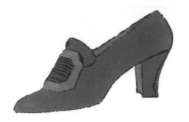

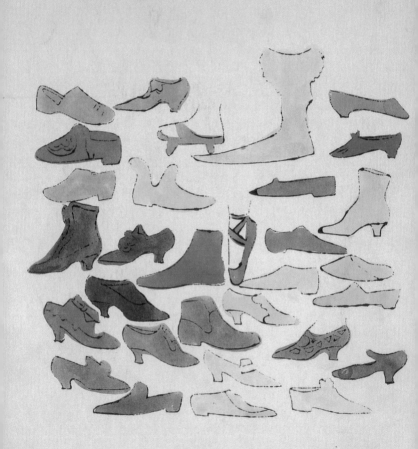

à La Recherche
du Shoe Perdu
by Andy Warhol

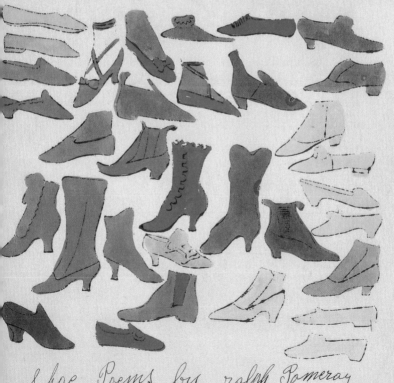

Shoe Poems by ralph Pomeroy

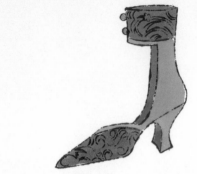

When I'm Calling Shoe.

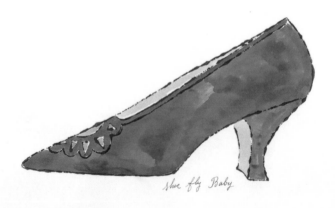

shoe fly Baby

Beauty is shoe, shoe beauty …

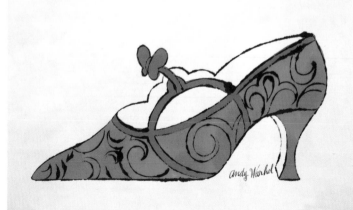

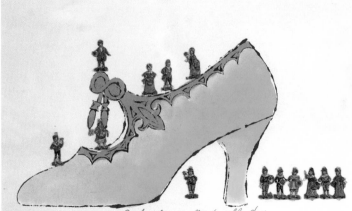

See a shoe and Pick it up and all day
long you'll have Good Luck

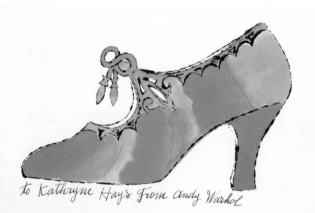

to Kathryne Hays From Andy Warhol

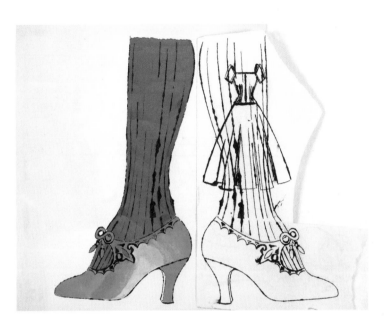

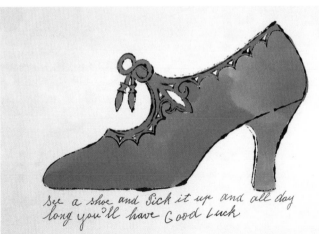

see a shoe and Pick it up and all day long you'll have Good Luck

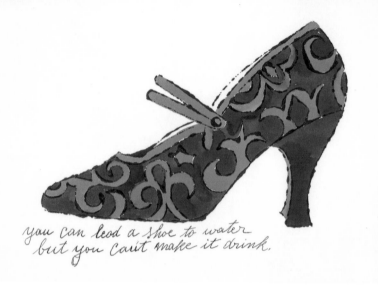

you can lead a shoe to water
but you can't make it drink.

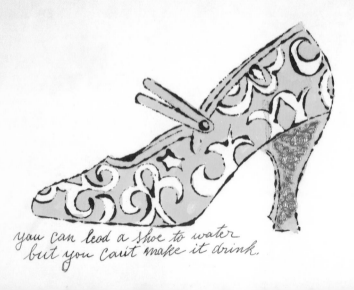

you can lead a shoe to water
but you can't make it drink.

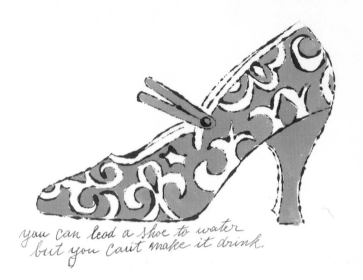

you can lead a shoe to water but you can't make it drink.

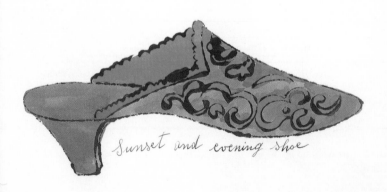

Sunset and evening shoe

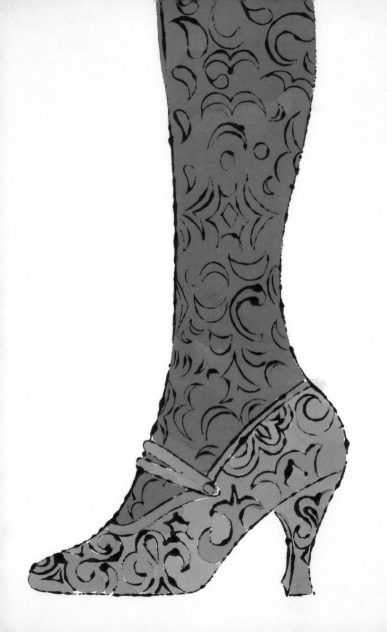

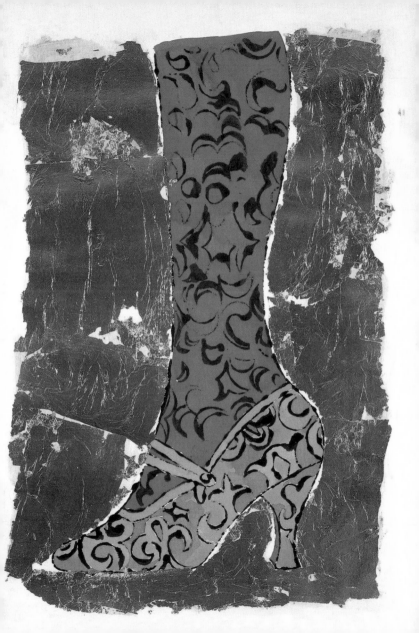

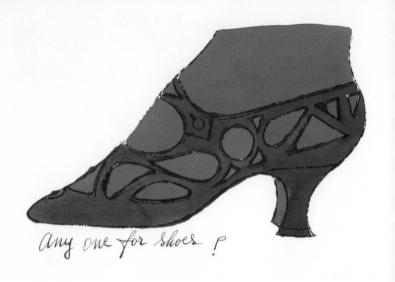

any one for shoes !

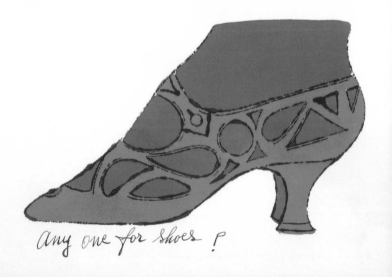

any one for shoes !

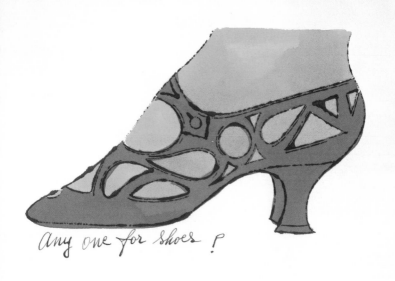

Any one for shoes !

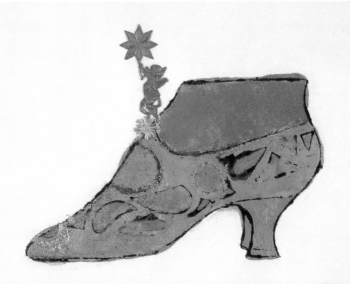

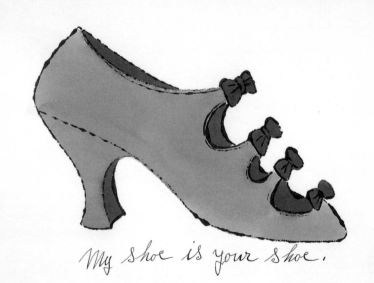

My shoe is your shoe.

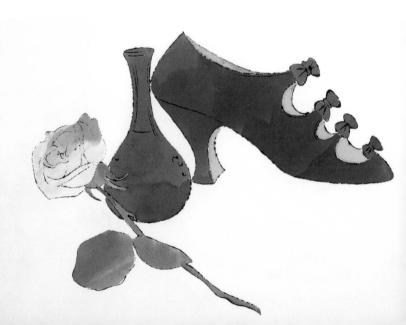

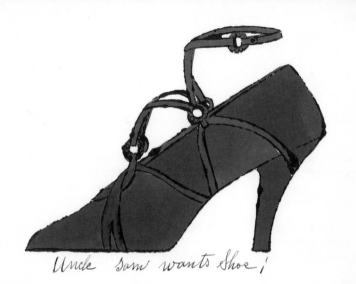

Uncle Sam wants Shoe;

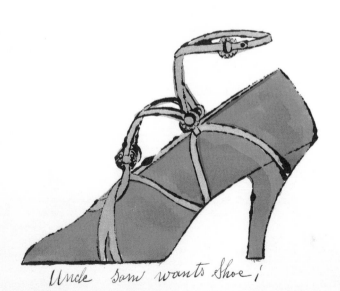

Uncle Sam wants Shoe;

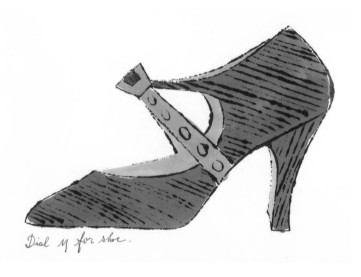

Dial M for shoe.

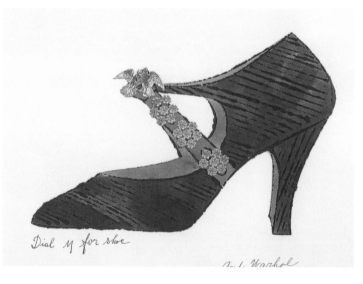

Dial M for shoe

Andy Warhol

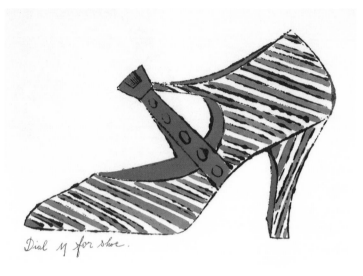

Dial M for shoe.

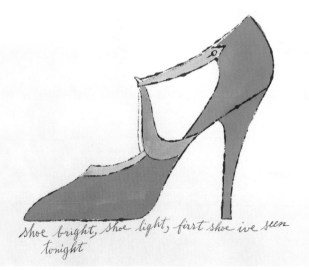

shoe bright, shoe light, first shoe ive seen
tonight

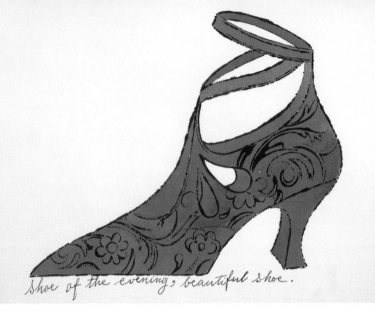

Shoe of the evening, beautiful shoe.

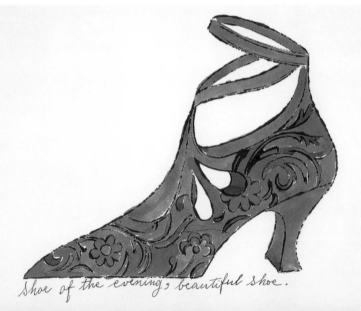

Shoe of the evening, beautiful shoe.

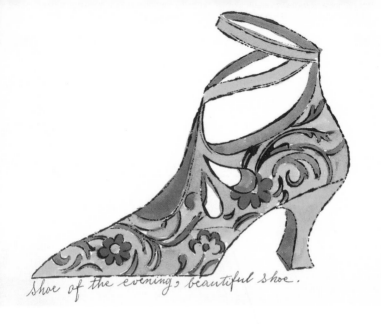

shoe of the evening, beautiful shoe.

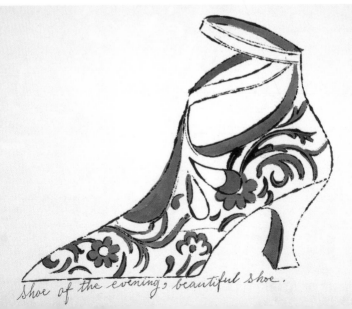

shoe of the evening, beautiful shoe.

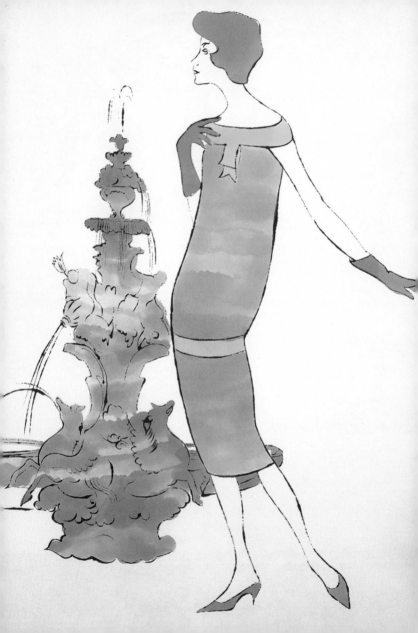

Beautiful people are sometimes more prone to keep you waiting than plain people are because there's a big time differential between the beautiful and the plain.

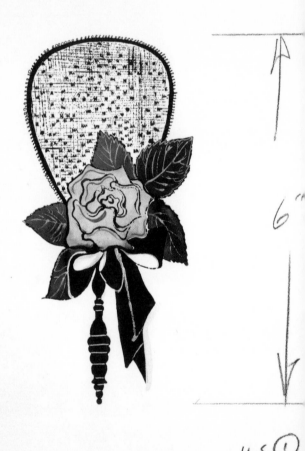

6"

↑

6"

INS ①
6" d

COMBO LINE &
HALFTONE DROP
OUT WHITE

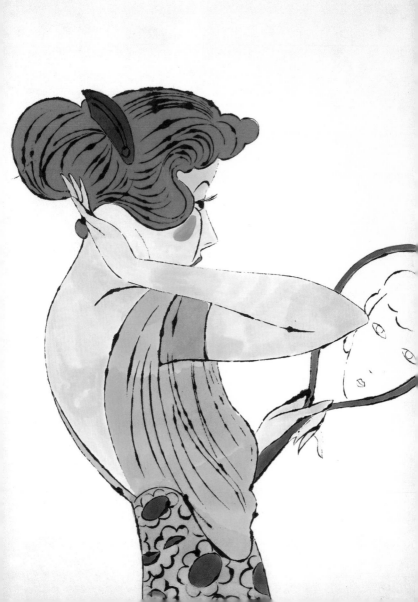

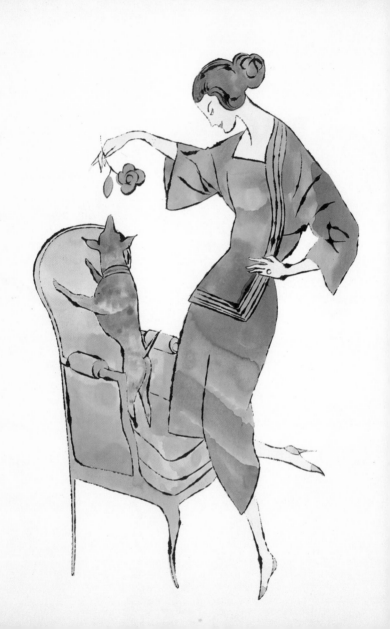

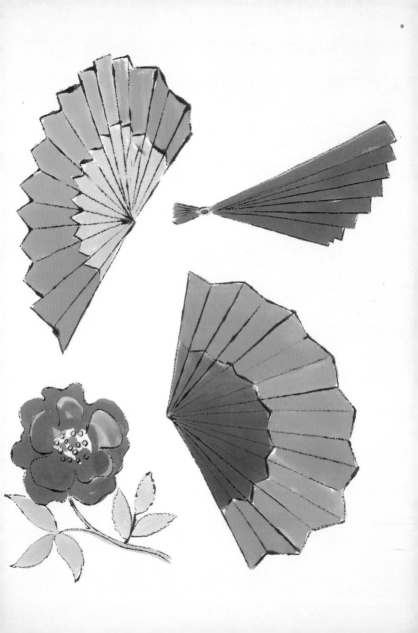

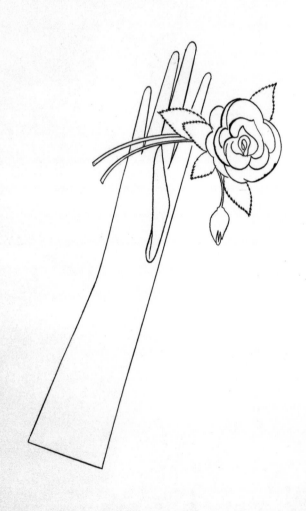

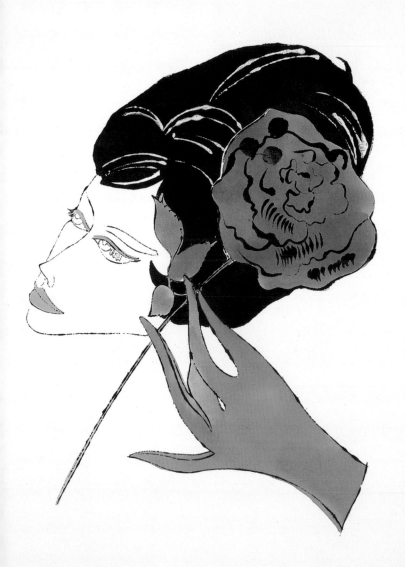

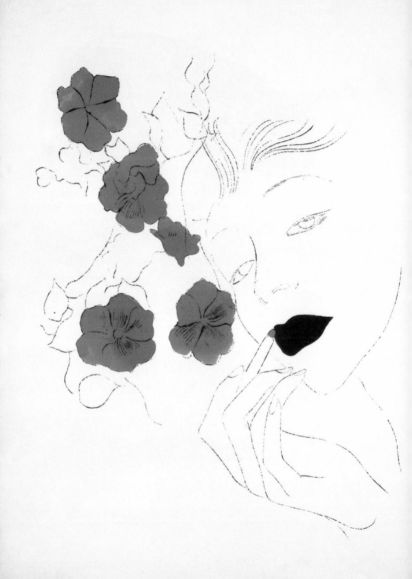

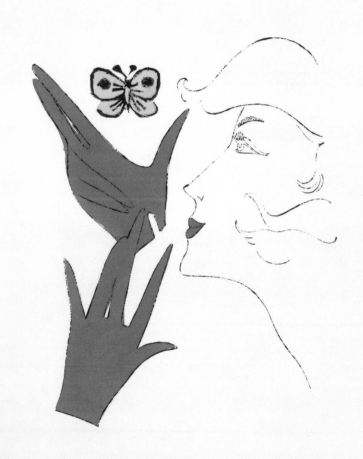

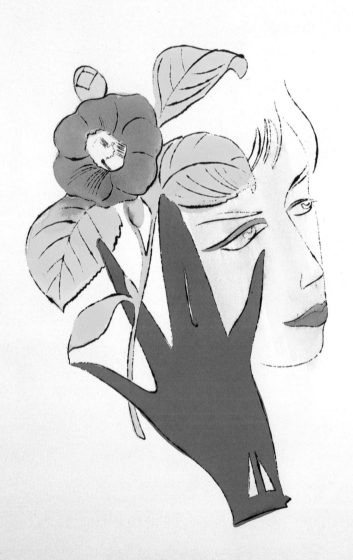

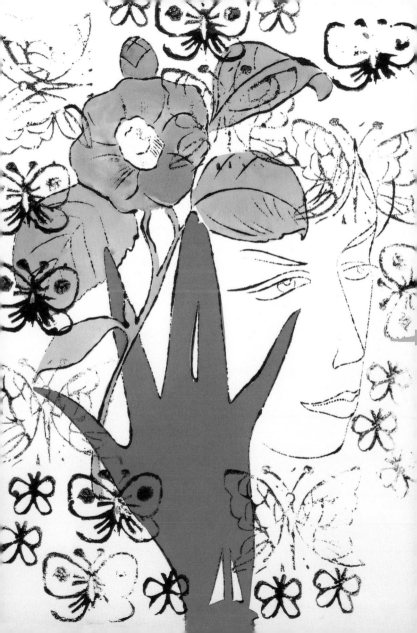

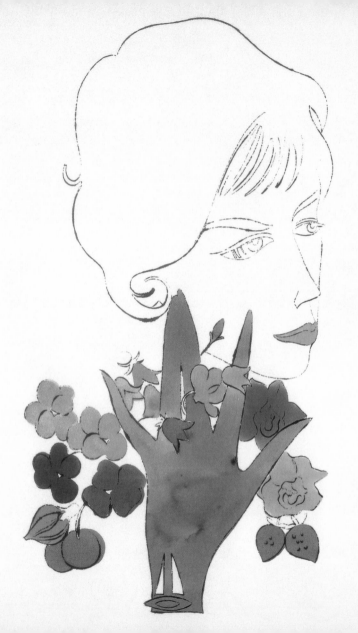

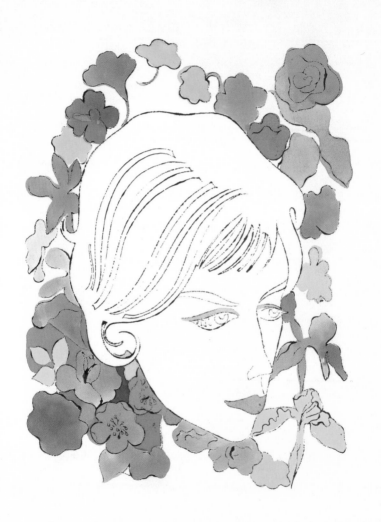

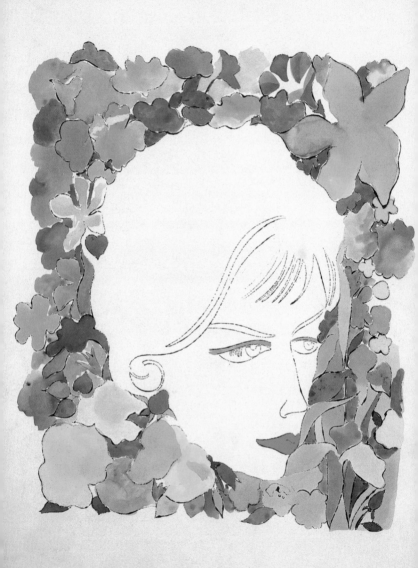

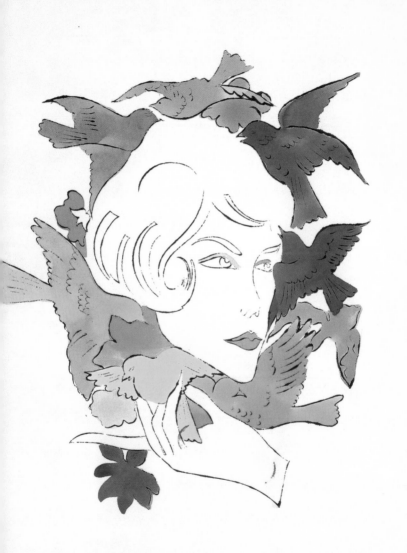

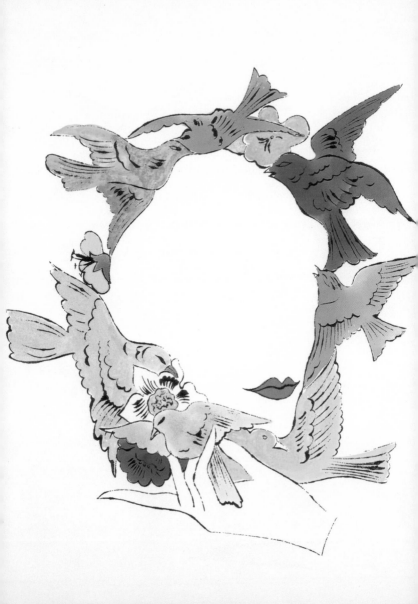

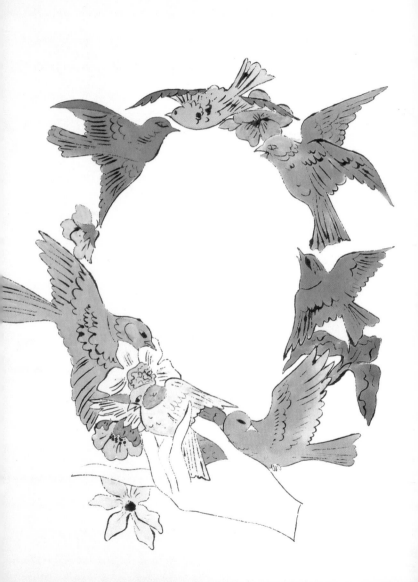

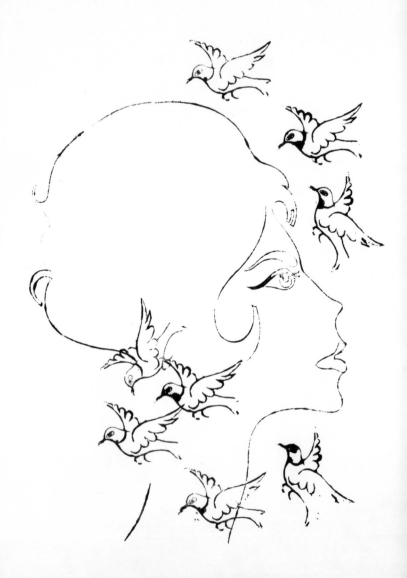

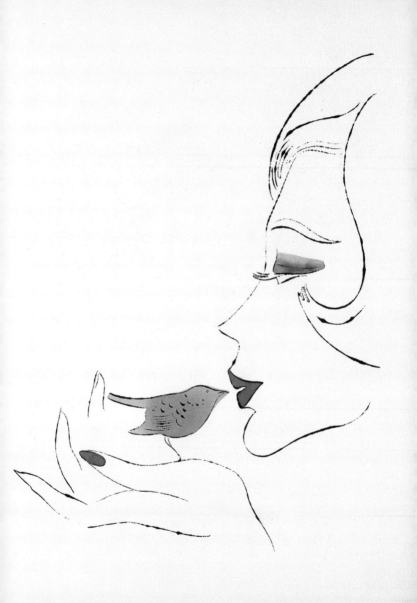

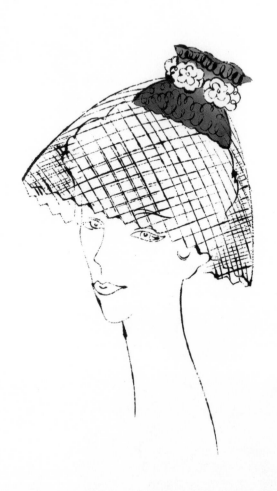

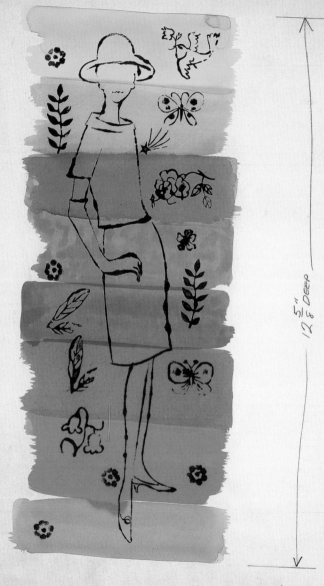

5" DEEP
12 8

SILHOUETTE

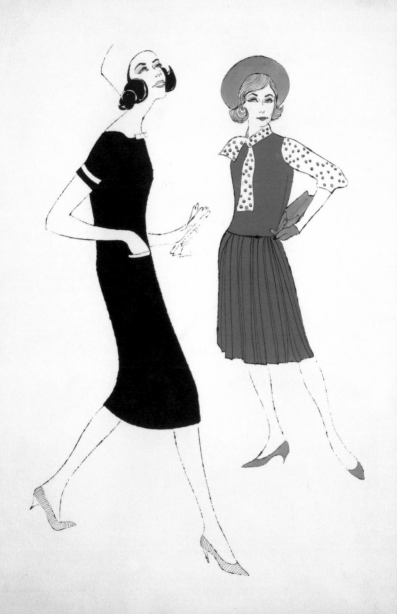

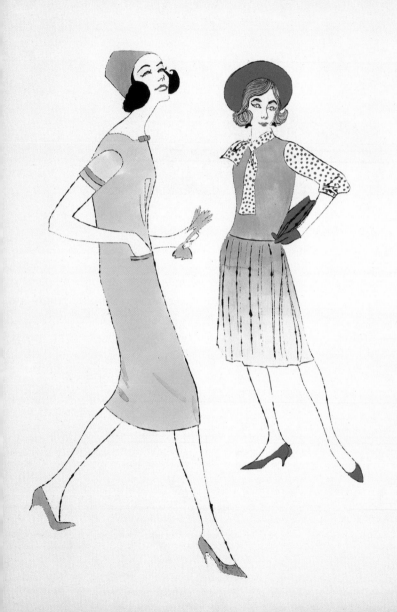

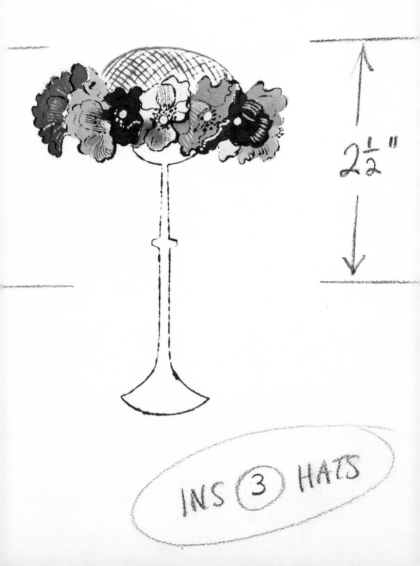

$2\frac{1}{2}$"

INS ③ HATS

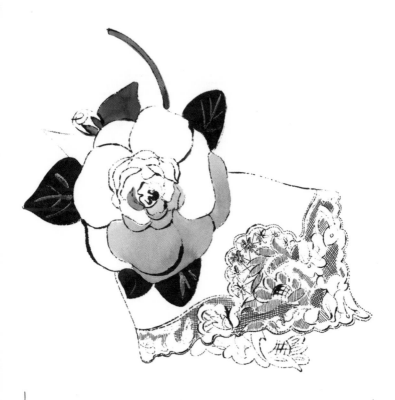

$3\frac{3}{4}$" WIDE

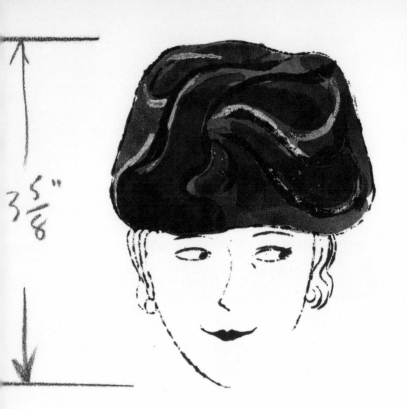

$3\frac{5}{8}''$

INS ① SHEATH

FASH. SPECIAL

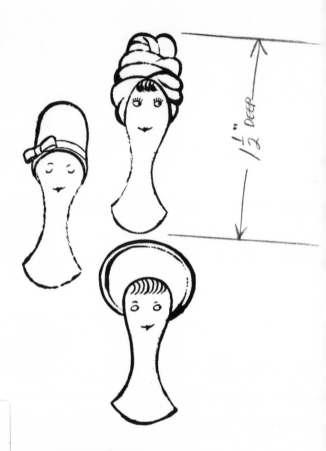

$1\frac{1}{2}"$ DEEP

LINE

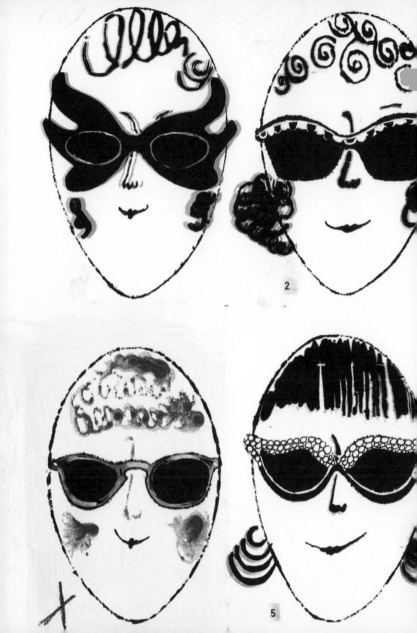

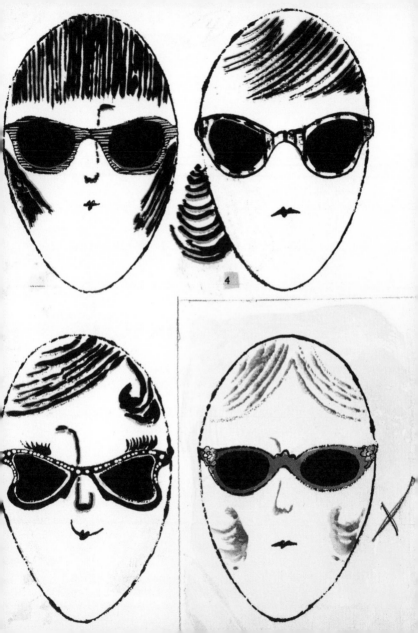

4

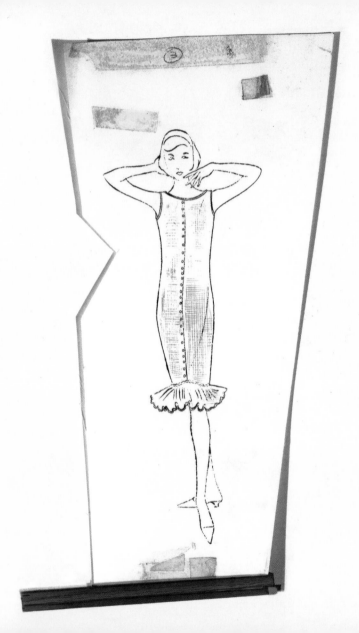

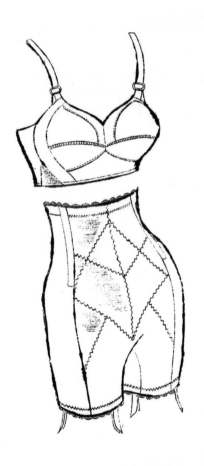

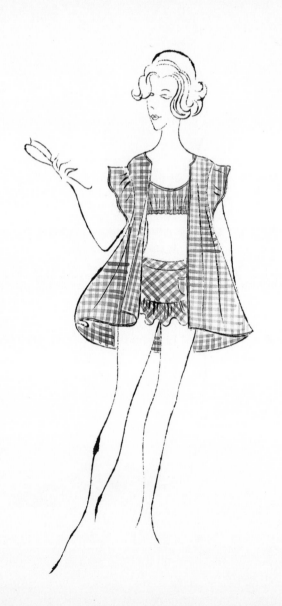

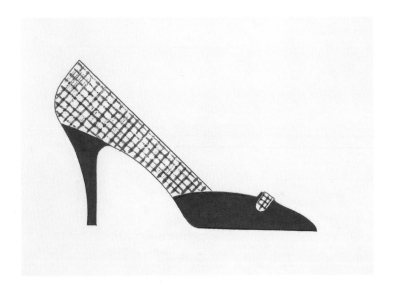

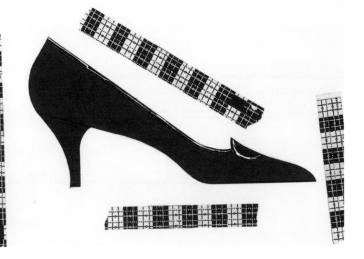

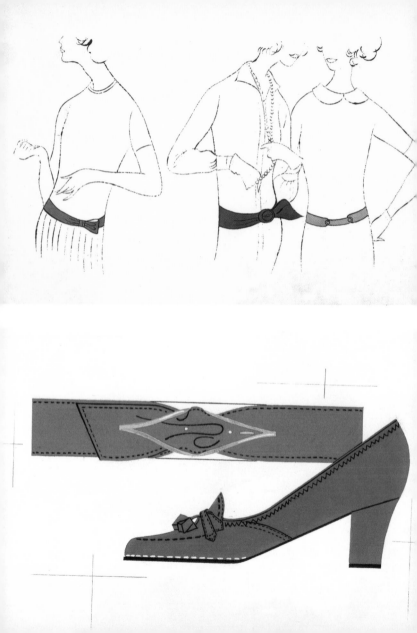

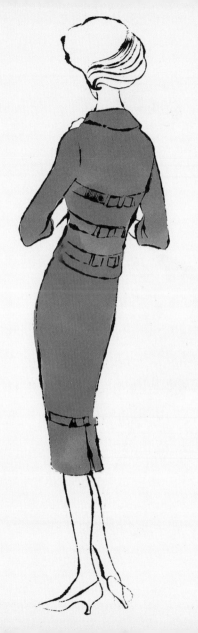

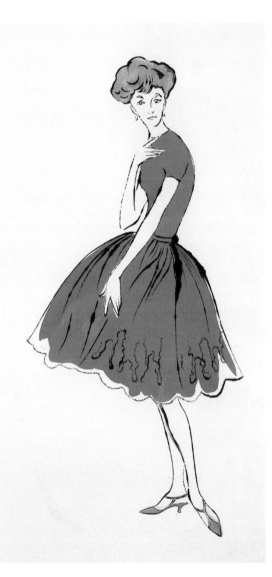

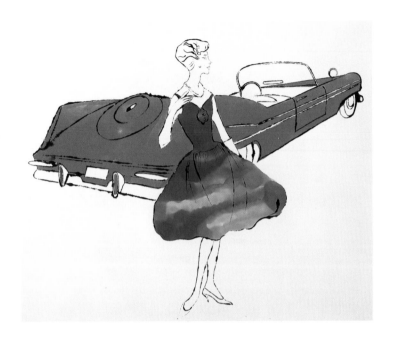

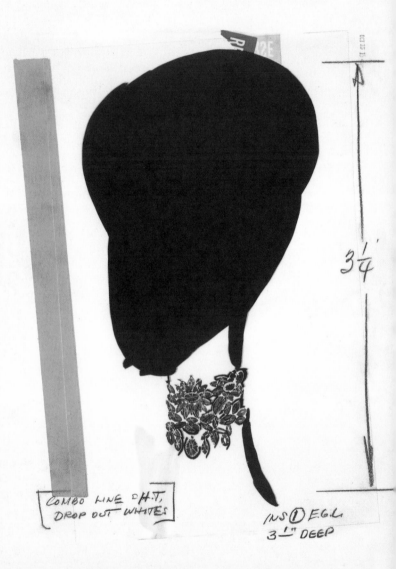

COMBO LINE D H.T,
DROP OUT WHITES

$3\frac{1}{4}$

INS ① E.G.L.
$3\frac{1}{4}''$ DEEP

Jewelry doesn't make a person more beautiful, but it makes a person feel more beautiful.

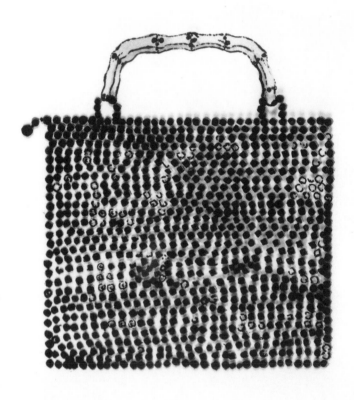

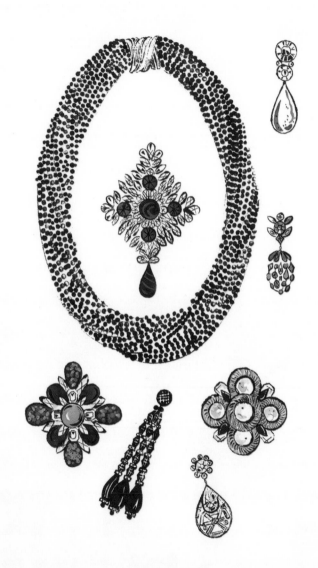

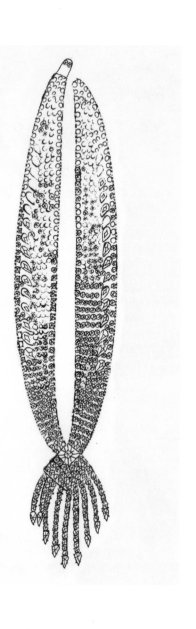

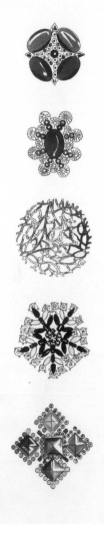

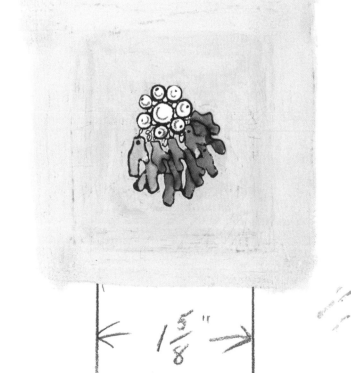

$1\frac{5}{8}$"

#5

DROP
OUT
WHITES

P-76

Fashion Special

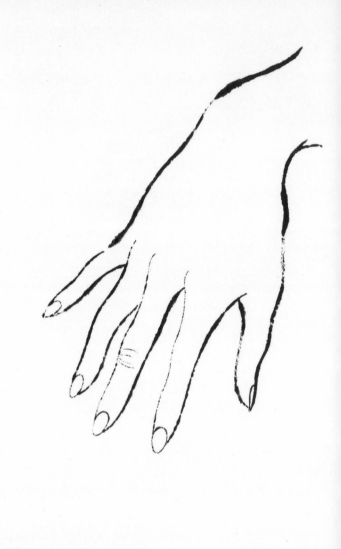

2¾" WIDE

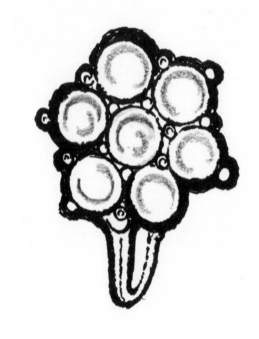

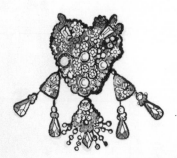

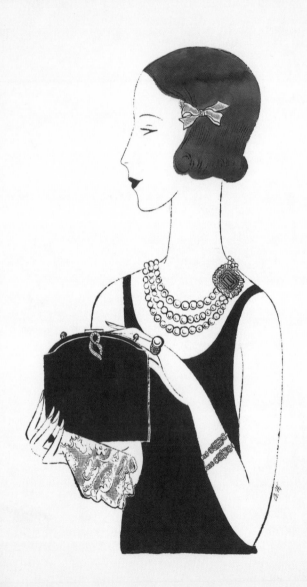

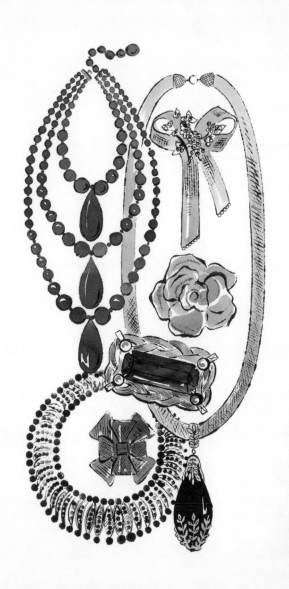

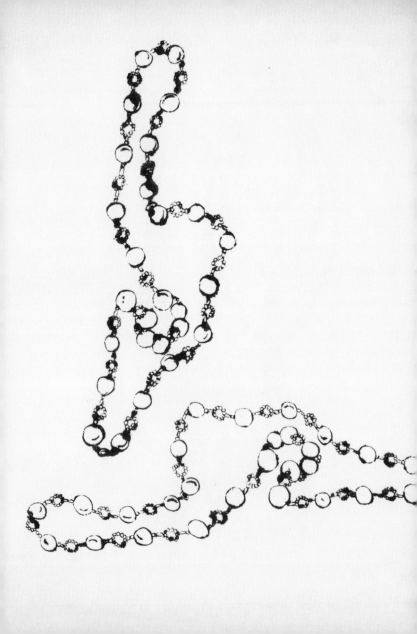

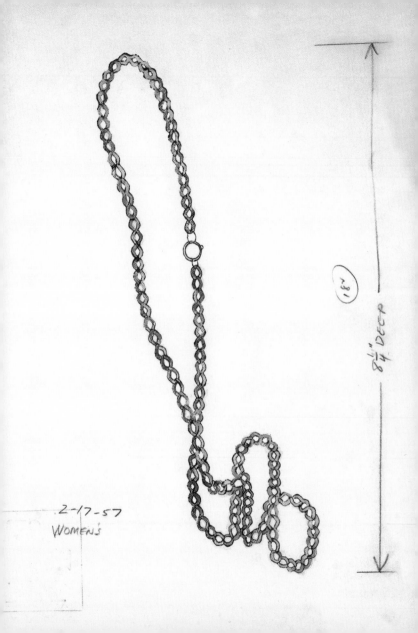

2-17-57
WOMEN'S

181

8¼" DEEP

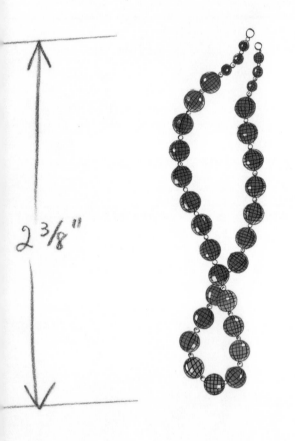

2 3/8"

INS ⑩ FASH

⑤

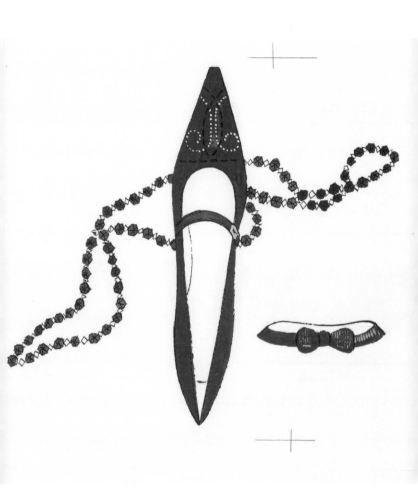

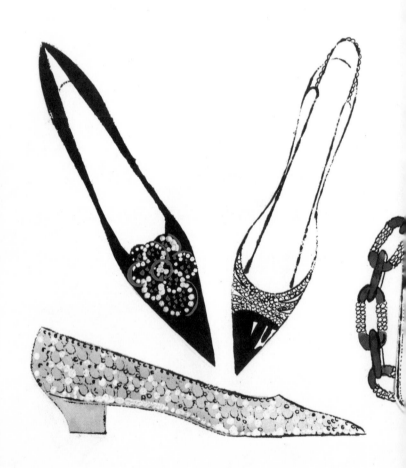

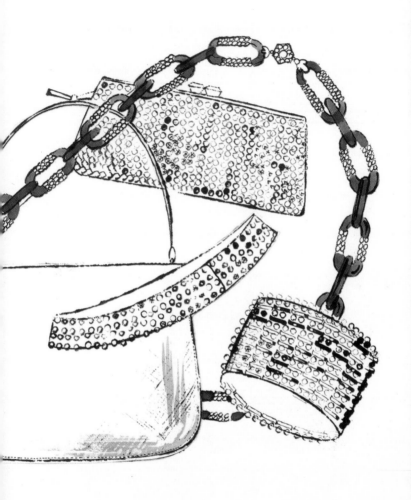

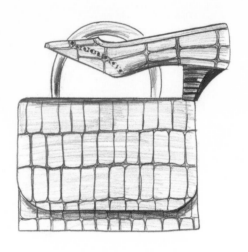

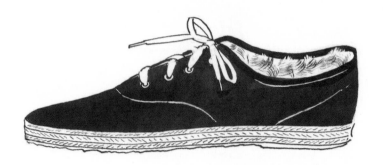

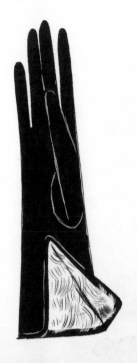

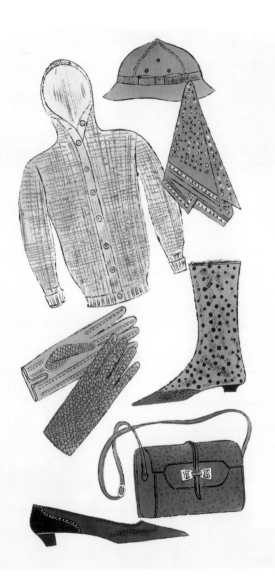

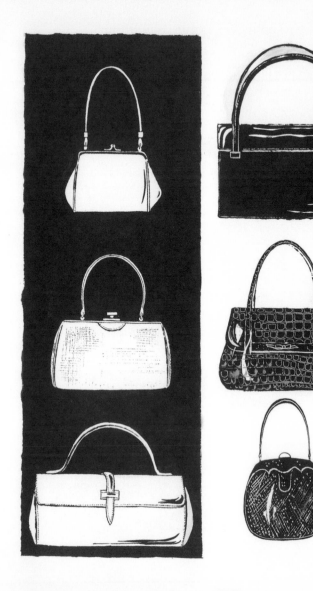

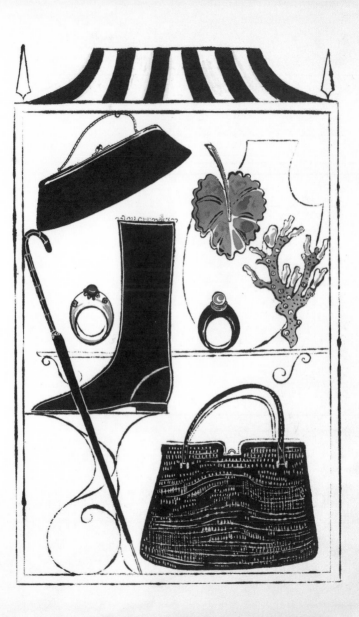

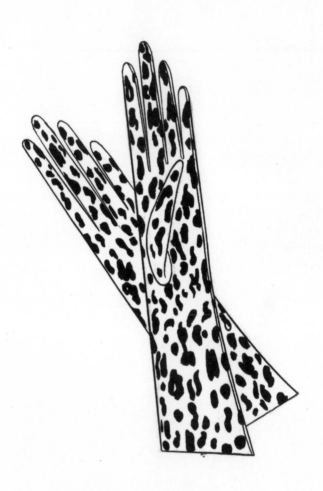

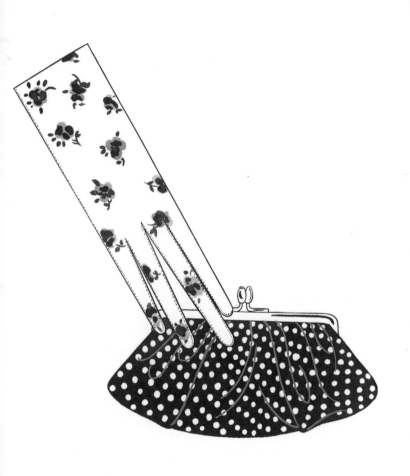

COMBINATION JOB
DROP OUT WHITES
SILHOUETTE

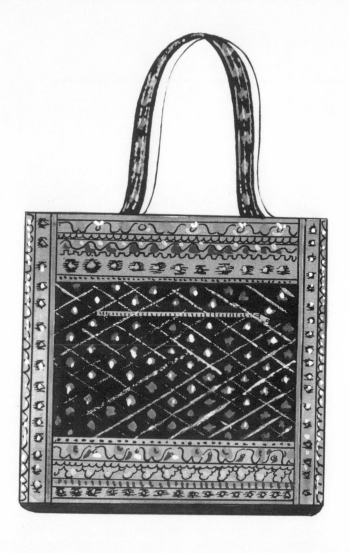

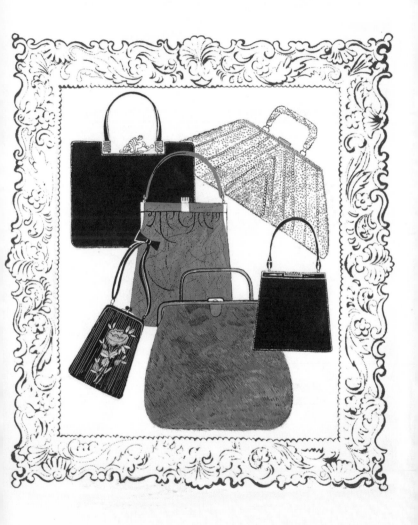

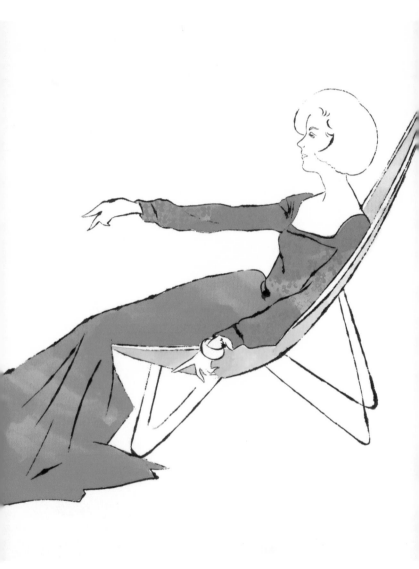

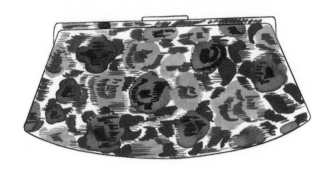

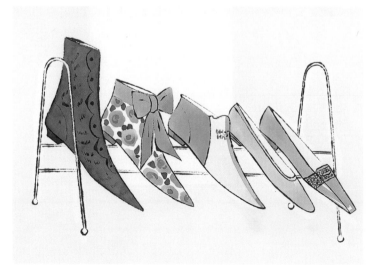

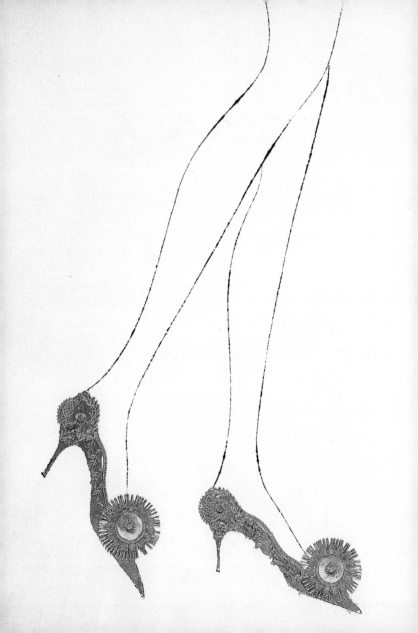

When you think about it, department stores are kind of like museums.

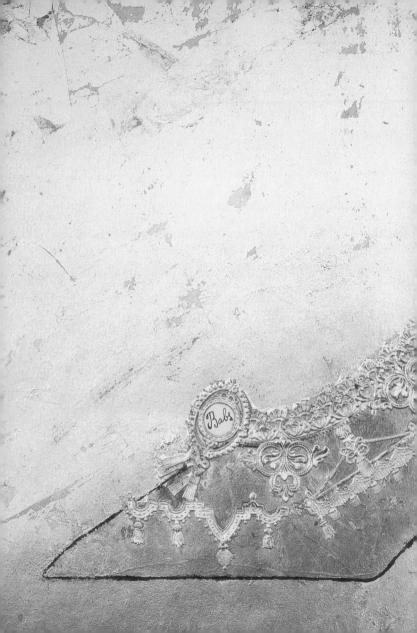

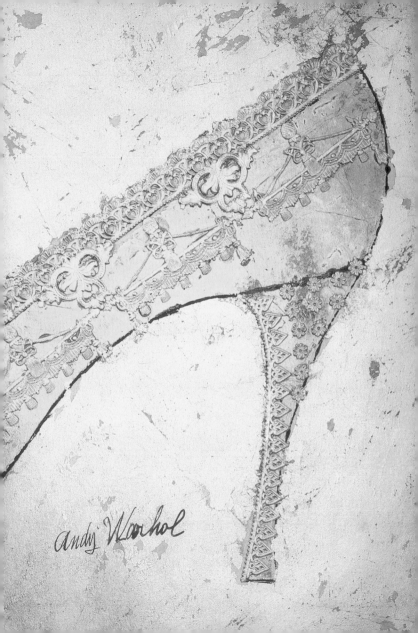

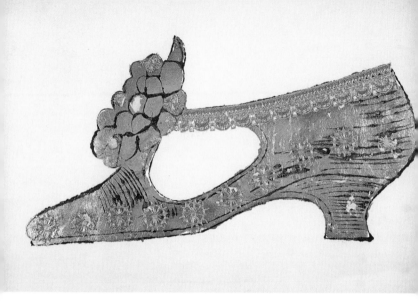

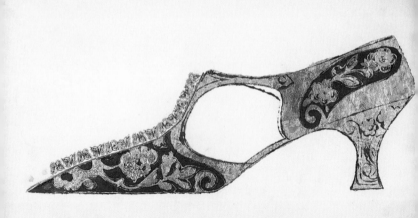

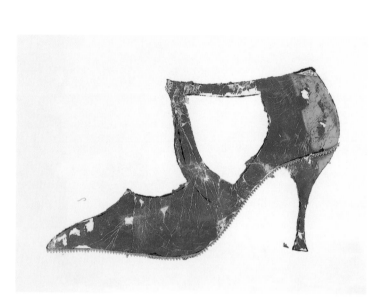

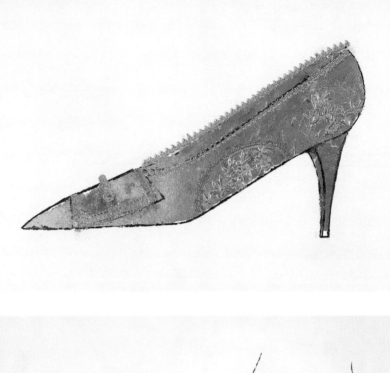

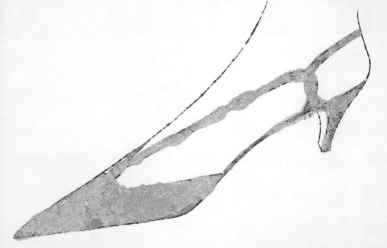

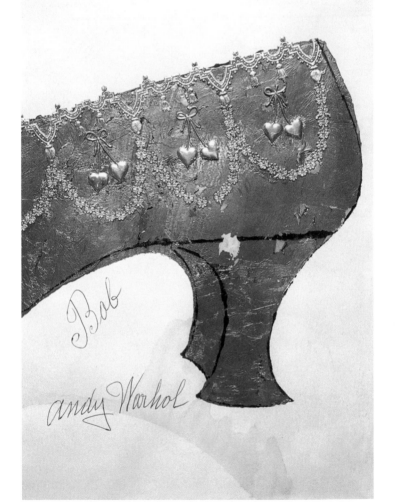

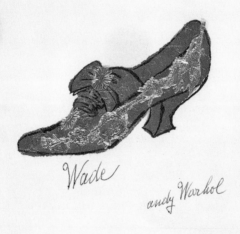

Wade

andy Warhol

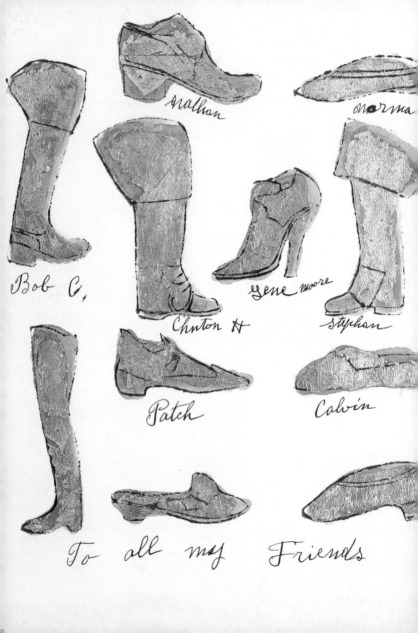

Nathan

Norma

Bob C,

Gene moore

Clinton H

Stephan

Patch

Calvin

To all my Friends

Everything in your closet should have an expiration date on it the way milk and bread and magazines and newspapers do.

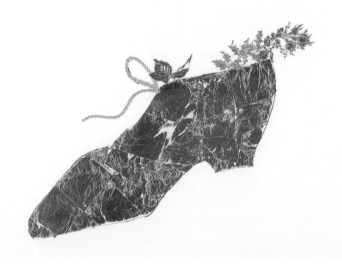

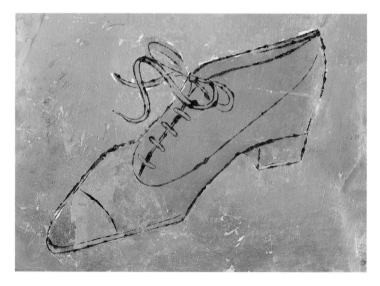

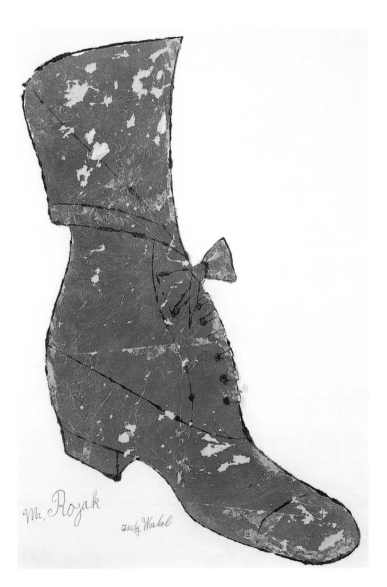

M. Rojak

andy Warhol

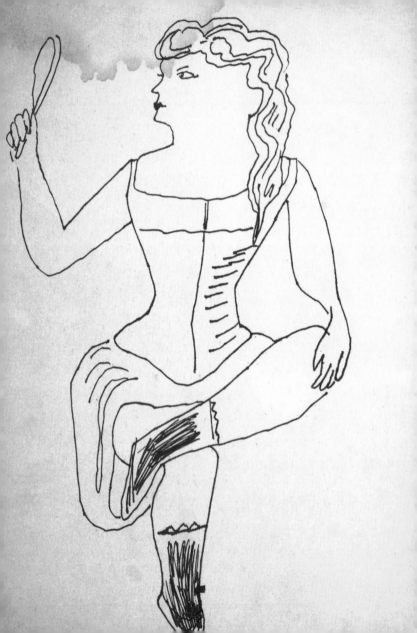

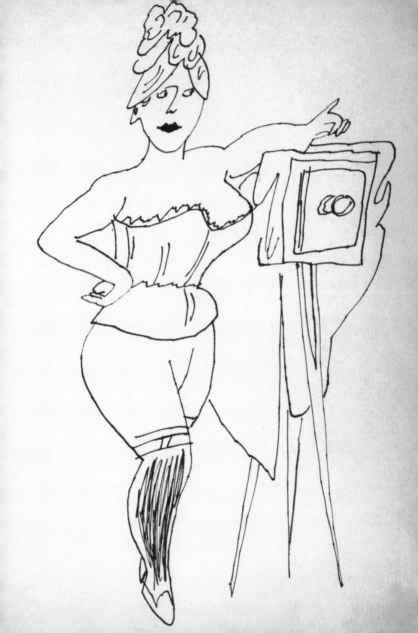

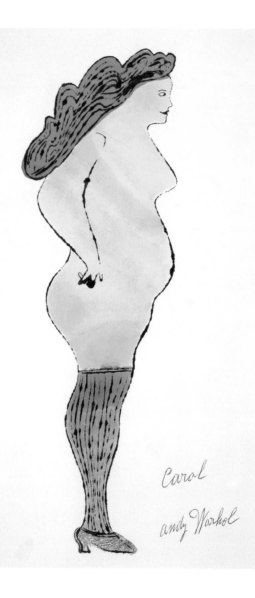

Carol

andy Warhol

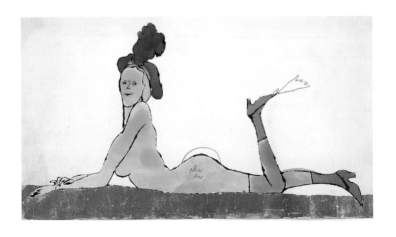

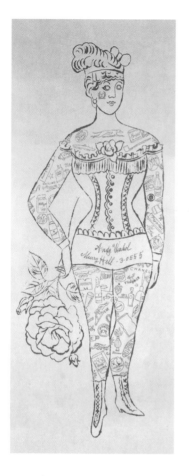
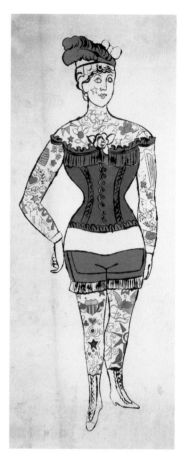

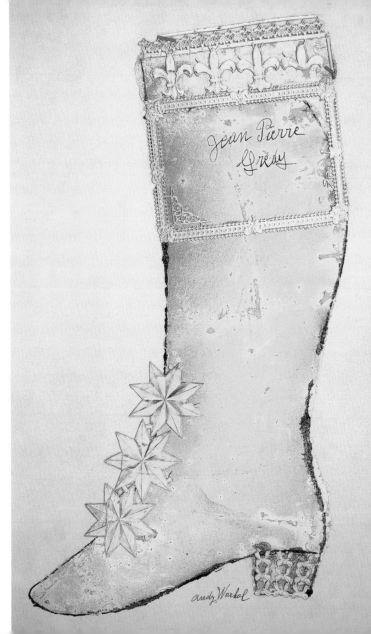

Jean Pierre
Grédy

andy Warhol

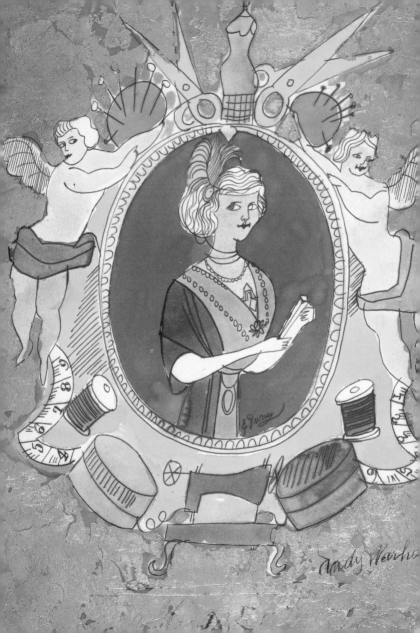

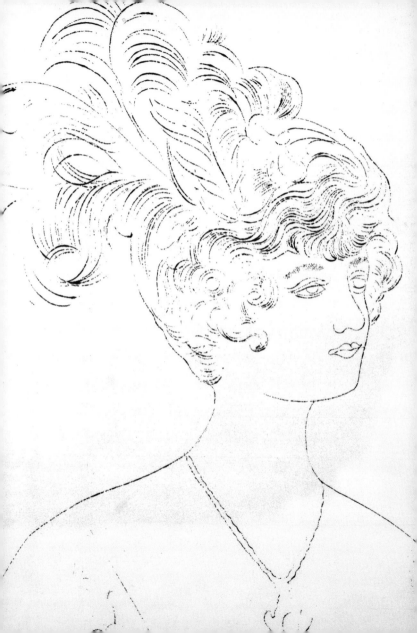

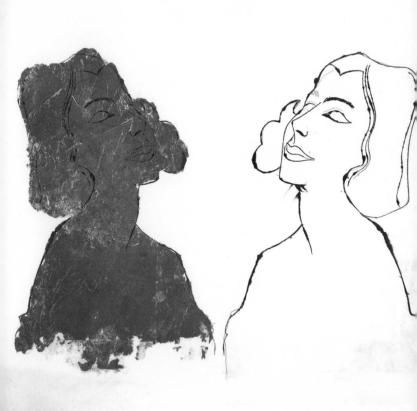

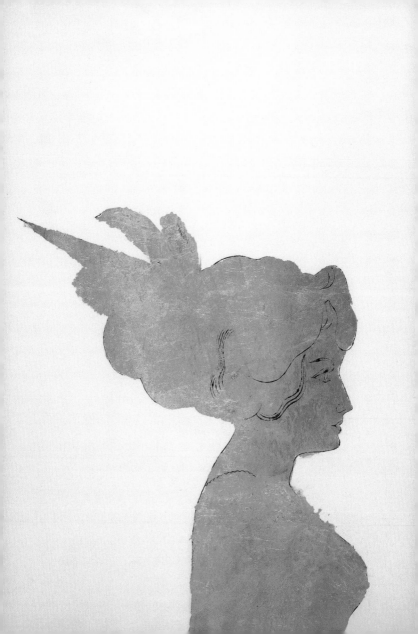

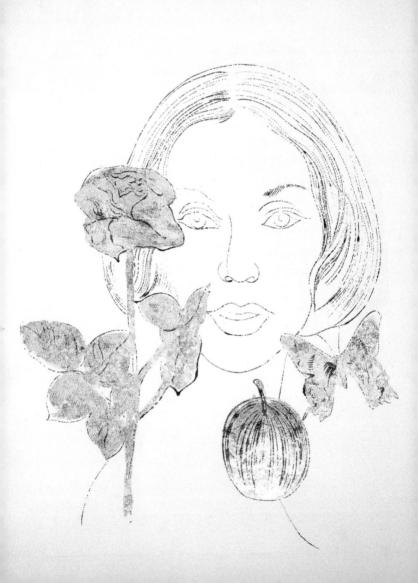

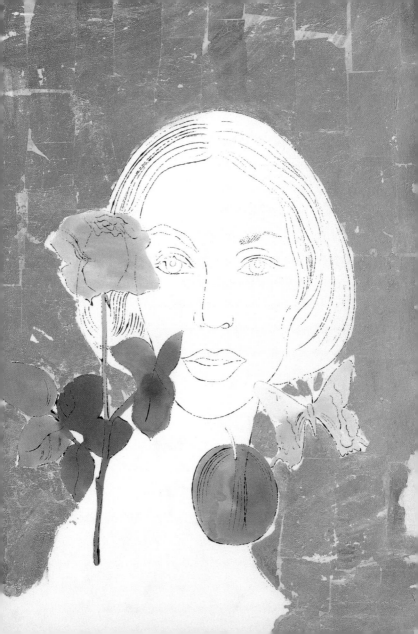

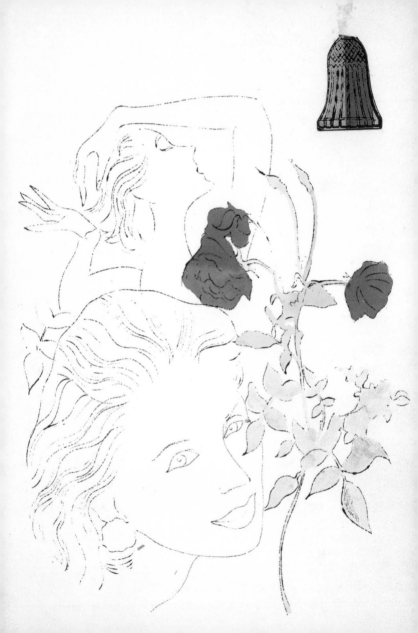

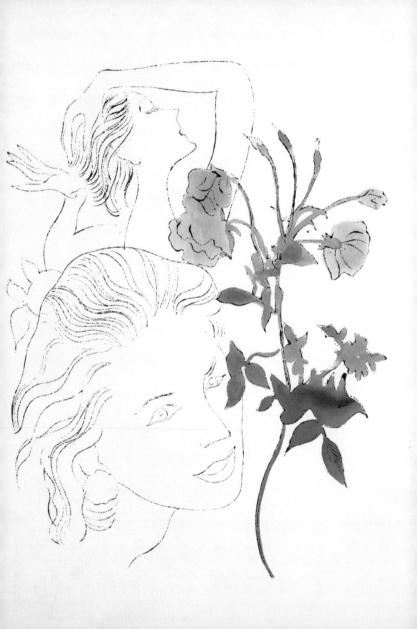

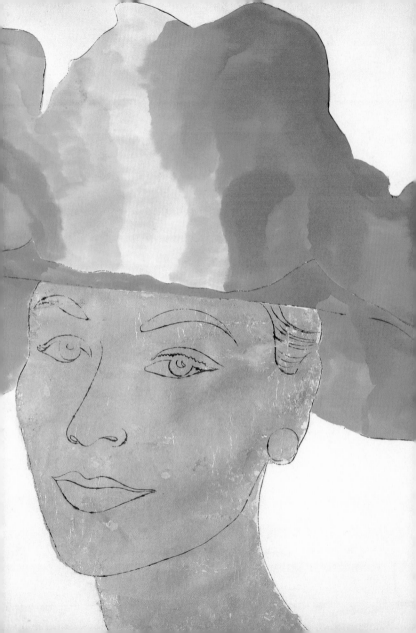

I loved working when I worked at commercial art and they told you what to do and how to do it and all you had to do was correct it and they'd say yes or no.

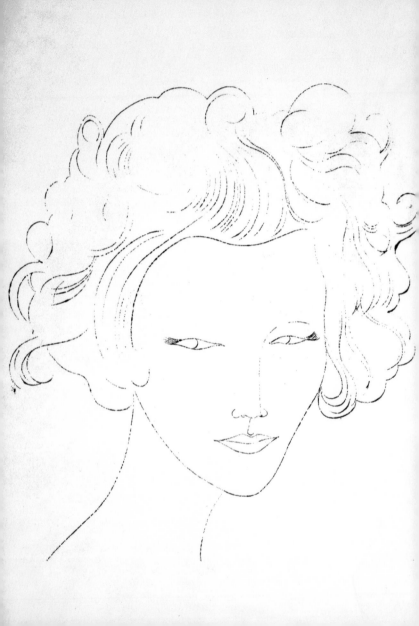

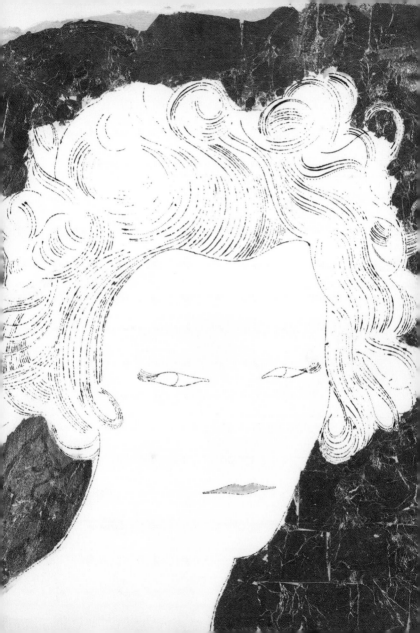

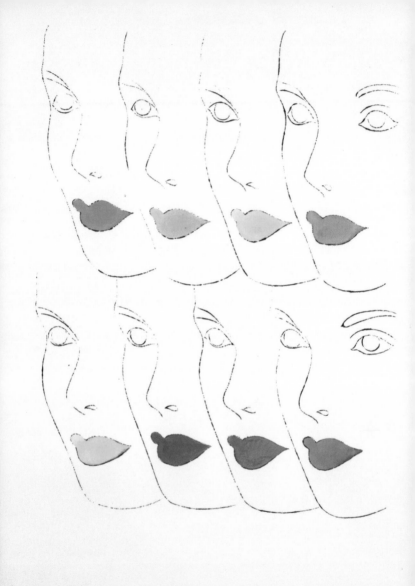

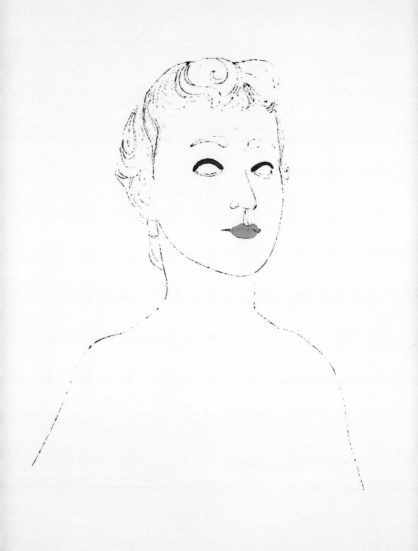

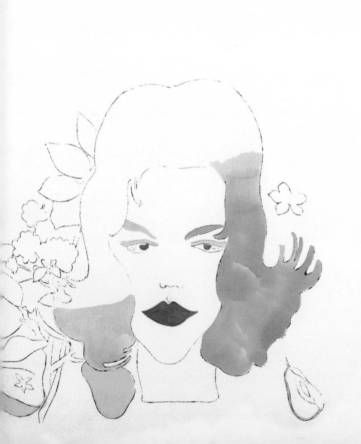

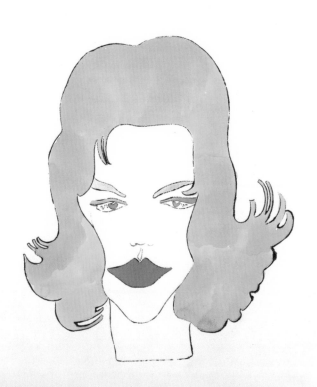

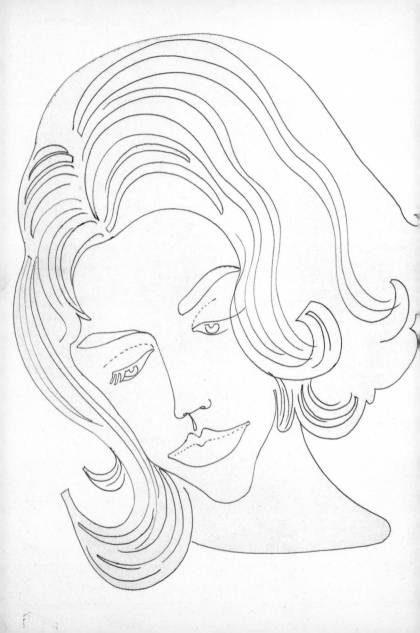

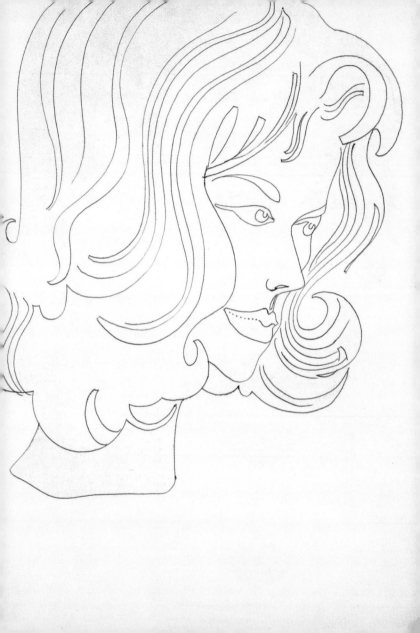

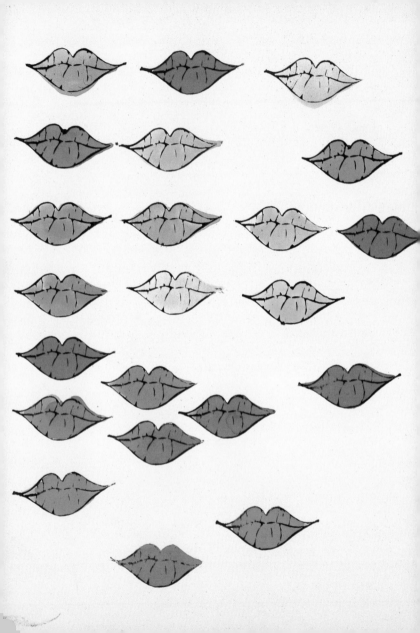

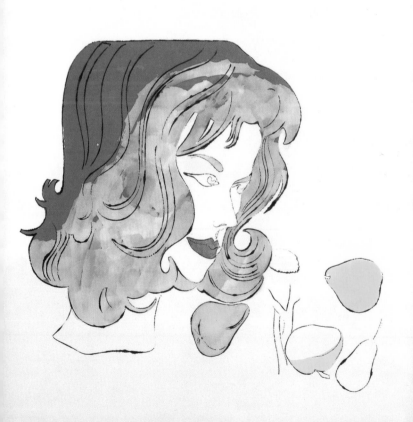

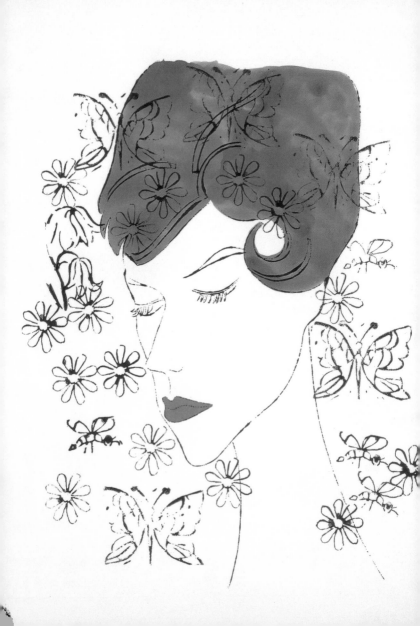

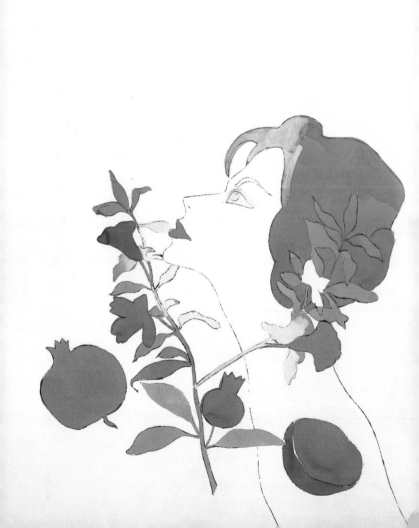

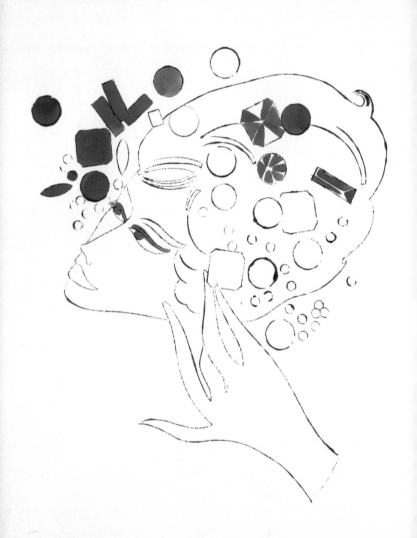

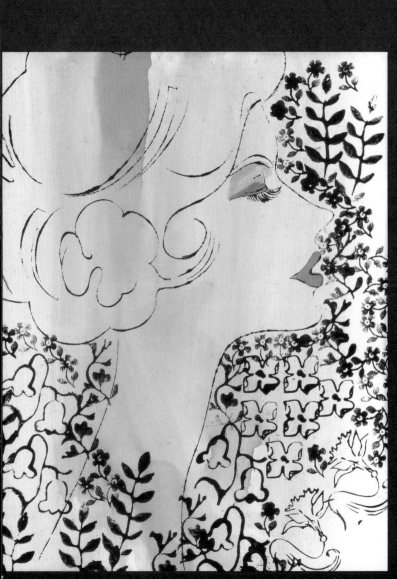

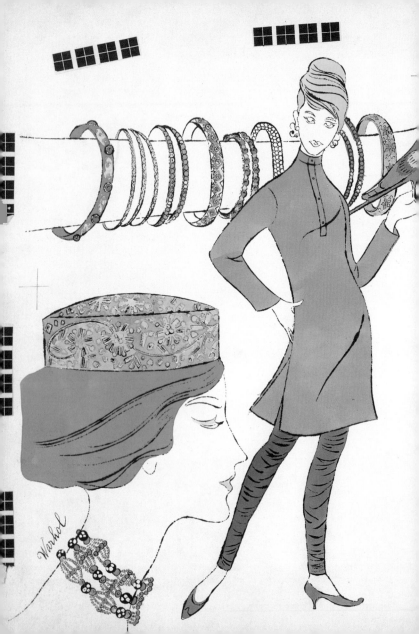

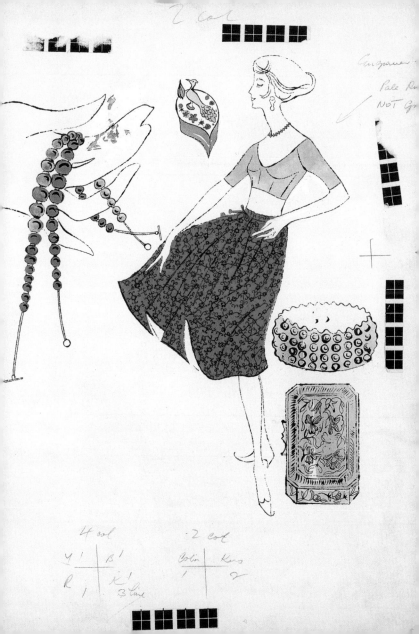

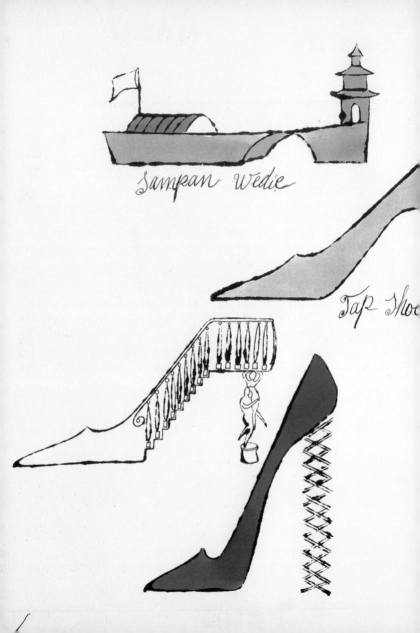

Sampan Wedie

Tap Shoe

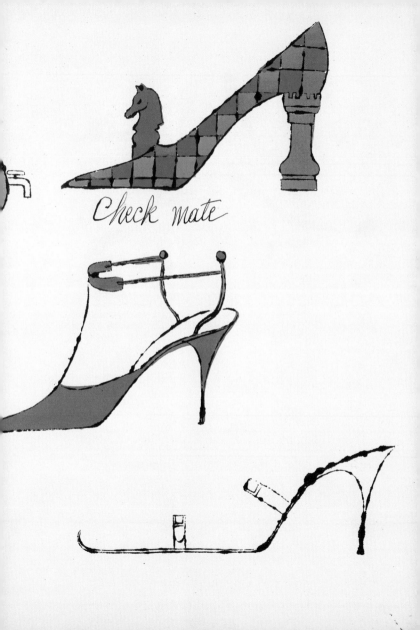

Check mate

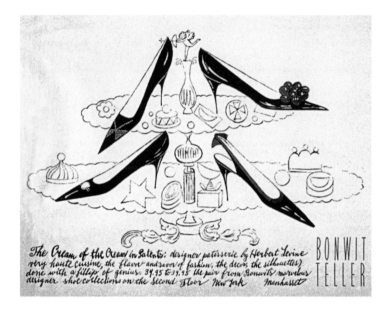

The Cream of the Cream in Patents: designer patisserie by Herbert Levine
very haute cuisine, the flavor and savor of fashion; the decor, the silhouettes
done with a fillip of genius. 39.95 to 39.95 the pair from Bonwits' marvelous
designer shoe collections on the second floor New York Manhasset

BONWIT TELLER

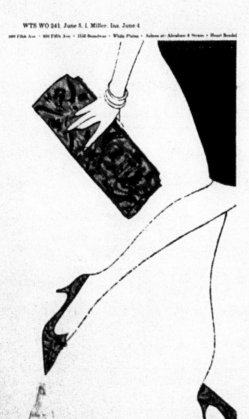

Summer Wools: freshest fashion in print. Soft, wondrously cool and porous (ask any sheik in the desert.) Millerkins' brown, red or green printed pump, 21.95. Matching envelope, 17.95. From our 450 Collection of warm weather excitements and shoestring prices. **I. Miller**

...rtswear Designer Puts Her Personal Theories Into Practice for Travel

Paris bithday coat is piped high in an Empire line. Has tiny Peter Pan collar and full-minute fits pockets. $59.95.

Curry-colored suede session is back with gold dots buttons from chin to waist. $64.95. Flannel skirt to knit.

Roman suede skirt-jacket teams up with tweed skirt and matching tag tote for travel unit. Belt, $29; slip, $58; $86.95.

Fussy black cocktail coat is made air-light in a small sack and can be worn over everything. Fits full cut back. $159.95.

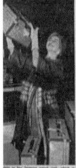

Old Bridal Styles Viewed in Suffolk

Shop Talk
Last-Minute Ideas to Remember Mother

Fashion Tip

Not One, but 7 Little Helpers Make Life Easier for Westchester Mother

...d: New Restaurant
...'s Branch in Garden City, Wich ...ecky Isl MA, to Open Tomorrow

Time Marches On in Shapes for Clocks

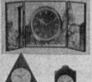

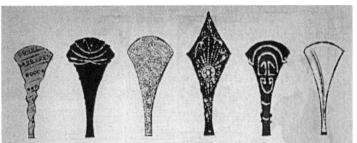

BY EVINS: SILVERED BAMBOO, SWAGGED SATIN, RHINESTONE PAVE, BEJEWELLED VIEWPOINT, EASTERN ELEGANCE, GOLDEN STILT

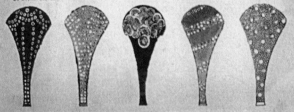

BY I. MILLER: GEMMED LACQUER, RHINESTONES AND SILVER, COIN COLLECTION, CANDY CANE GLITTER, SEEDED PEARLS

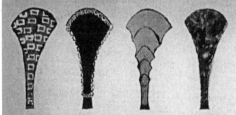

BY INGENUE: POLISHED MOSAIC, SEQUIN PIPINGS, PAGODA-CARVED CALF, MOCK TORTOISE

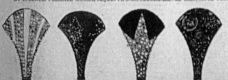

BY MILLERKINS: STRIPED BRILLIANTS, BRONZE GLITTER, BLACK COLLARED SPARKLER, BROCADE

THIS IS THE WELL-HEELED LOOK OF FASHION; ON PUMPS, ON SANDALS... BY DAY, BY DUSK, BY NIGHT.
INFINITE VARIETY, FROM 21.95 TO 75.00 ... ALL EXCLUSIVE I.Miller

[1] *Buttons*, c. 1959; Ink and Dr. Martin's aniline dye on Strathmore paper; 10⅛ x 9¼ in.

[2] *Female Head with Stars*, c. 1959; Stamped gold, stamped ink, and Dr. Martin's aniline dye on Strathmore paper; 15⅛ x 14¾ in.

[5] *Female Fashion Figure*, c. 1959; Ink and Dr. Martin's aniline dye on Strathmore Seconds paper; 28⅝ x 22½ in.

[6] *Shoe Tip with Ruffled Edge*, c. 1959; Ink on Strathmore paper; 23 x 15½ in.

[8] Bonwit Teller window display, 1955.

[11] *Female Fashion Figure*, c. 1960; Ink and Dr. Martin's aniline dye on Strathmore paper; 22⅞ x 14½ in.

[12] *"Who's Pussyfooting Around?"* c. 1960; Ink on Strathmore paper; 19 x 14⅜ in.

[14] *Python Shoe (Fleming Joffe)*, c. 1958; Ink and white paint on Strathmore paper; 23 x 15¾ in.

[15] [left] *Female Fashion Figure with Shadow*, c. 1959; Ink on Strathmore paper; 23 x 7⅜ in.

[15] [right] *Female Fashion Figure with Shadow*, c. 1959; Ink on Strathmore paper; 22 x 8¾ in.

[16] *Female Fashion Figure*, c. 1960; Ink and wash on Strathmore paper; 23 x 17 in.

[17] *Female Fashion Figure*, c. 1960; Ink and tempera on Strathmore paper; 23 x 16 in.

[18] *Female Fashion Figure*, c. 1960; Ink and tempera on Strathmore paper; 23 x 18 in.

[19] *Female Fashion Figure*, c. 1960; Ink and wash on Strathmore paper; 23 x 17 in.

[20] *Female Fashion Figure*, c. 1960; Ink and wash on Strathmore paper; 23 x 10½ in.

[21] *Female Fashion Figure*, c. 1960; Ink, wash and graphite on Strathmore paper; 23 x 15 in.

[22–23] *Three Female Fashion Figures*, c. 1959; Ink, wash, and tempera on Strathmore paper; 14 x 23 in.

[24] *Female Fashion Figure*, c. 1959; Ink and wash on Strathmore paper; 22 x 8½ in.

[25] *Dress with Jacket*, c. 1959; Ink and Dr. Martin's aniline dye on Strathmore paper; 23 x 14¼ in.

[26] *Female Fashion Figure and Female Head*, c. 1959; Ink and graphite on Strathmore paper; 17½ x 16 in.

[27] *Two Female Fashion Figures*, c. 1959; Ink on Strathmore paper; 22⅝ x 18¼ in.

[28] *Six Skirts with Two Short Pants*, c. 1959; Ink and tempera on Strathmore paper; 23 x 14¼ in.

[29] *Shoe and Leg* (detail), c. 1956; Ink and Dr. Martin's aniline dye on Strathmore paper; 23 x 16¼ in.

[30] Illustration for fashion layout, c. 1950s.

[31] *Shoe and Angel*, c. 1957; Ink on Strathmore Seconds paper; 14⅝ x 22½ in.

[32] *Female Head*, c. 1957; Ink on Strathmore paper; 22⅝ x 15½ in.

[33] *"Here Lies the Heart,"* c. 1957; Ink on colored graphic art paper collage; 11¾ x 9 in.

[34] *Tondo (Hands with Flowers)*, c. 1958; Ink, graphite, and Dr. Martin's aniline dye on Strathmore paper; 23 x 15⅜ in.

[36] *Tondo (Female with Leaves and Flowers)*, c. 1958; Ink, graphite, and Dr. Martin's aniline dye on Strathmore paper; 14½ x 13⅜ in.

[37] [top] *Two Fairies*, c. 1955; Ink, wash, and tempera on Strathmore paper; 21½ x 14½ in.

[37] [bottom] *"Frosty Mist Cologne,"* c. 1958; Ink and tempera on Strathmore paper; 21⅛ x 10¾ in.

[38] *Female Hands Flowers and Eyes*, c. 1958; Ink and Dr. Martin's aniline dye on Strathmore paper; 22½ x 16 in.

[39] *Female Hands, Flowers and Eyes*, c. 1958; Ink and Dr. Martin's aniline dye on Strathmore paper; 20 x 12¼ in.

[40] *Female Head and Hands Applying Eyeliner*, c. 1955; Ink

41 *Cosmetics and Cosmetic Accessories*, c. 1962; Graphite, Dr. Martin's aniline dye, and colored graphic art paper collage on Strathmore paper; 29 x 23 in.

42 *Lipstick and Case*, c. 1958; Ink on Strathmore paper; 11⅞ x 9 in.

43 *Perfume Bottles and Lipstick*, c. 1962; Graphite and Dr. Martin's aniline dyes on Strathmore paper; 29 x 23 in.

44 *Cosmetics*, 1962; Graphite, oil pastel, and photo collage on Strathmore paper; 29 x 23 in.

45 *Cosmetics*, 1962; Graphite, oil, pastel, and photo collage on Strathmore paper; 29 x 23 in.

46 *Santa Claus and Perfume Bottles*, 1962; Graphite on Strathmore paper; 29 x 23 in.

47 *Christmas Sewing Theme*, c. 1957; Ink and Dr. Martin's aniline dye on Strathmore paper; 15⅜ x 9 in.

48 {top} *Toiletries*, c. 1958; Ink, Dr. Martin's aniline dye, and stamped ink on Strathmore paper; 22⅝ x 28⅝ in.

48 {bottom} *Toiletries*, c. 1958; Ink, Dr. Martin's aniline dye, and stamped ink on Strathmore paper; 22⅝ x 29⅛ in.

49 *Perfume Bottle*, c. 1953; Ink on Strathmore paper; 9⅝ x 6⅞ in.

50 *Male Fashion Figure*, c. 1960; Ink and tempera on Strathmore paper; 29 x 15½ in.

52 *Cufflinks*, 1957; Ink on Strathmore paper; 14½ x 11⅝ in.

53 *Male Fashion Figure*, c. 1960; Ink and tempera on Strathmore paper; 26⅞ x 15 in.

54 *Male Fashion Figure*, c. 1960; Ink on board; 21⅞ x 12 in.

55 *Male Fashion Figure*, c. 1960; Ink on Strathmore paper; 23⅜ x 12½ in.

56 *"Bond Street by Yardley" Perfume*, 1960; Ink and tempera on Strathmore paper; 11⅞ x 10¼ in.

57 *Male Fashion Figure*, c. 1960; Ink and graphite on Strathmore paper; 22⅞ x 15⅝ in.

58 *Male Fashion Figure*, c. 1960; Ink on Strathmore paper; 26½ x 15¼ in.

59 *Male Fashion Figure*, c. 1960; Ink, tempera, and Dr. Martin's aniline dye on Strathmore paper; 26¾ x 13⅞ in.

60 *Scarf*, c. 1955; Ink and tempera on Strathmore paper; 14½ x 13⅝ in.

61 *Standing Male*, c. 1958; Ink, Dr. Martin's aniline dye, and tempera on Strathmore paper; 23⅛ x 28⅞ in.

62 *Seated Male*, c. 1959; Ink, Dr. Martin's aniline dye, and tempera on Strathmore paper; 23 x 15 in.

63 *Seated Male*, c. 1958; Ink and Dr. Martin's aniline dye on Strathmore paper; 17¼ x 12⅝ in.

64 Illustration for *Harper's Bazaar*, July, 1958.

66 *Two Shoes with Bows (Top View)*, c. 1958; Ink on Strathmore paper; 16¼ x 22⅞ in.

67 *Shoe Tip with Ruffled Edge*, c. 1957; Ink on Strathmore paper; 23 x 15½ in.

68 *Shoe Tip with Sidelace*, c. 1960; Ink on Strathmore paper; 16¾ x 9½ in.

69 *Shoe Tip with Lace*, c. 1958; Ink on Strathmore paper; 22⅞ x 17 in.

70 *Two Shoes*, c. 1960; Ink and tempera on Strathmore paper; 11½ x 15¾ in.

71 *Man's Foot, Women's Foot and Purse*, c. 1957; Ink on Strathmore paper; 14⅜ x 11½ in.

72 {top} *Shoe*, c. 1960; Ink on Strathmore paper; 11⅝ x 14⅜ in.

72 {bottom} *High Heel*, c. 1960; Ink on Strathmore paper; 11½ x 14⅜ in.

73 *Shoe and Sock*, 1955; Ink and tempera on Strathmore paper; 12½ x 8¾ in.

74 *Three Shoe Tips*, c. 1960; Ink on Strathmore paper; 18¼ x 12⅞ in.

75 {top} *High Heel*, c. 1958; Ink on Strathmore paper; 6½ x 7 in.

75 {bottom} *High Heel*, c. 1958; Ink on board; 5½ x 9½ in.

76 *Feet in High Heels*, c. 1955; Ink on Strathmore paper; 13½ x 10⅞ in.

77 *Feet in High Heels*, c. 1955; Ink and tempera on Strathmore paper; 14½ x 10 in.

78 *Pair of Legs in High Heel*, c. 1958; Ink on Strathmore paper; 23 x 16⅜ in.

79 Untitled (Shoe Radiating from Center), c. 1958; Ink and Dr. Martin's aniline dye on Strathmore paper; 23 x 22⅝ in.

80 *High Heel*, c. 1958; Ink and graphite on Strathmore paper; 5¾ x 6¼ in.

81 (top) *Shoe*, c. 1959; Ink and wash on Strathmore paper; 8¾ x 11 in.

81 (bottom) *Shoe*, c. 1955; Ink, wash, and tempera on Strathmore paper; 14 x 21¾ in.

82 (top) *Five Shoes*, c. 1957; Ink and wash on Strathmore paper; 15¼ x 20¼ in.

83 (bottom) *Five Shoes*, c. 1960; Ink on white paper; 24 x 18 in.

84 *Shoe*, c. 1960; Ink and tempera on Strathmore paper; 14⅜ x 10¼ in.

85 *Five Shoes*, c. 1959; Ink, wash, and tempera on Strathmore paper; 13⅞ x 21¾ in.

86 *Five High Heels*, c. 1960; Ink and tempera on Strathmore paper; 13⅞ x 10½ in.

87 *Pair of Legs in High Heels*, c. 1960; Ink on Strathmore paper; 14½ x 18 in.

88 *Two Pairs Ladies' Legs and Sign*, c. 1960; Ink on Strathmore paper; 19½ x 14½ in.

89 (top) *Shoe*, c. 1959; Ink and wash on Strathmore paper; 10½ x 13 in.

89 (bottom) *Shoe with Pattern*, c. 1958; Ink and wash on Strathmore paper; 10¾ x 10½ in.

90 *Shoe and Lower Leg*, c. 1956; Ink on Strathmore paper; 23⅜ x 16½ in.

91 *Leg in High Heel Sandal*, c. 1960; Ink and tempera on Strathmore paper; 16⅜ x 11¾ in.

92 (top) *High Heel*, c. 1958; Ink on Strathmore paper; 10½ x 14⅜ in.

92 (bottom) *High Heel*, c. 1960; Ink and tempera on Strathmore paper; 11⅞ x 16 in.

93 (top) *Stamped Shoe with 1961 Postal Stamps*, c. 1961; Ink and Dr. Martin's aniline dye on Strathmore paper; 14¼ x 22⅝ in.

93 (bottom) *Stamped Shoe with Butterflies*, c. 1961; Ink and tempera on Strathmore Seconds paper; 14⅜ x 22½ in.

94 (top) *High Heel Shoe (P.M. Morningstar)*, c. 1955; Ink and Dr. Martin's aniline dye on Strathmore paper; 8½ x 11⅝ in.

94 (bottom) *High Heel Shoe*, c. 1955; Ink and Dr. Martin's aniline dye on Strathmore paper; 11½ x 15¼ in.

95 (top) *High Heel*, c. 1958; Graphite and Dr. Martin's dye on Strathmore paper; 23 x 12¼ in.

95 (bottom) *Red High Heel*, c. 1958; Ink and Dr. Martin's aniline dye on Strathmore paper; 11½ x 14¼ in.

96 (top) *High Heel Sandal*, c. 1958; Ink on Strathmore paper; 5¼ x 7¼ in.

96 (bottom) *Feet in High Heels*, c. 1958; Ink on Strathmore paper; 15¾ x 23 in.

97 (top) *Shoe*, c. 1955; Ink and wash on Strathmore paper; 10⅜ x 12⅞ in.

97 (bottom) *Shoe*, c. 1958; Ink and wash on Strathmore paper; 10 x 13½ in.

98 *Legs in High Heel Sandals*, c. 1960; Ink on Strathmore paper; 12⅞ x 9¾ in.

99 *Shoe with Registration Marks*, c. 1955; Ink and tempera on Strathmore paper; 7 x 7⅞ in.

100 *Shoe with Registration Marks*, c. 1955; Ink and tempera on Strathmore paper; 7 x 8 in.

101 (top) *Shoe with Registration Marks*, c. 1958; Ink and tempera on Strathmore paper; 6¾ x 7½ in.

101 (bottom) *Shoe with Registration Marks*, c. 1960; Ink and tempera on Strathmore paper; 6 x 6½ in.

102 *Shoe*, c. 1960; Ink and tempera on Strathmore paper; 4⅜ x 8⅞ in.

103 *Shoe*, c. 1960; Ink and tempera on Strathmore paper; 5½ x 7¼ in.

104 (top) *"To Shoe or Not to Shoe"* (from: *A la Recherche du Shoe Perdu* by Andy Warhol, Shoe Poems by Ralph Pomeroy, 1955); Offset lithograph and watercolor on paper; 9¾ x 13¾ in.

104 (bottom) *"To Shoe or Not to Shoe"* (from: *A la Recherche du Shoe Perdu* by Andy Warhol, Shoe Poems by Ralph Pomeroy, 1955); Offset lithograph on paper; 9¾ x 13¾ in.

105 Untitled (Stamped Shoes), c. 1959; Ink and Dr. Martin's aniline dye on ivory sketchbook paper; 23¾ x 17⅝ in.

106 (top) *"I Dream of Jeannie with the Light Brown Shoes"* (from: *A la Recherche du Shoe Perdu* by Andy Warhol, Shoe

Poems by Ralph Pomeroy, 1955); Hand-colored offset lithograph on paper; 9¾ x 13¾ in.

106 (bottom) *"I Dream of Jeannie with the Light Brown Shoes"* (from: *A la Recherche du Shoe Perdu* by Andy Warhol, Shoe Poems by Ralph Pomeroy, 1955); Hand-colored offset lithograph on paper; 9¾ x 13¾ in.

107 (top) *"The Autobiography of Alice B. Shoe"* (from: *A la Recherche du Shoe Perdu* by Andy Warhol, Shoe Poems by Ralph Pomeroy, 1955); Offset lithograph and watercolor on paper; 9¾ x 13¾ in.

107 (bottom) *"In Her Sweet Little Alice Blue Shoes"* (from: *A la Recherche du Shoe Perdu* by Andy Warhol, Shoe Poems by Ralph Pomeroy, 1955); Hand-colored offset lithograph on paper; 9¾ x 13¾ in.

108 Back cover of *A la Recherche du Shoe Perdu* by Andy Warhol, Shoe Poems by Ralph Pomeroy, 1955; Offset lithograph and watercolor on paper; 19⅝ x 12⅞ in.

109 Front cover of *A la Recherche du Shoe Perdu* by Andy Warhol, Shoe Poems by Ralph Pomeroy, 1955; Offset lithograph and watercolor on paper; 19⅝ x 12⅞ in.

110 (top) *"When I'm Calling Shoe"* (from: *A la Recherche du Shoe Perdu* by Andy Warhol, Shoe Poems by Ralph Pomeroy, 1955); Offset lithograph and watercolor on paper; 9¾ x 13¾ in.

110 (bottom) *"Shoe Fly Baby"* (from: *A la Recherche du Shoe Perdu* by Andy Warhol, Shoe

Poems by Ralph Pomeroy, 1955); Offset lithograph and watercolor on paper; 9¾ x 13¾ in.

111 (top) *"Beauty Is Shoe, Shoe Beauty"* (from: *A la Recherche du Shoe Perdu* by Andy Warhol, Shoe Poems by Ralph Pomeroy, 1955); Offset lithograph and watercolor on paper; 9¾ x 13¾ in.

111 (bottom) *High Heel Shoe,* c. 1955; Ink and Dr. Martin's aniline dye on Strathmore paper; 14½ x 22⅝ in.

112 (top) *"See a Shoe and Pick It Up and All Day Long You'll Have Good Luck"* (from: *A la Recherche du Shoe Perdu* by Andy Warhol, Shoe Poems by Ralph Pomeroy, 1955); Hand-colored offset lithograph on paper; 9¾ x 13¾ in.

112 (bottom) *Shoe ("to Kathryne Hays from Andy Warhol"),* 1955; Ink, graphite, and Dr. Martin's aniline dye on Strathmore paper; 11⅞ x 13¾ in.

113 (top) *Shoe and Leg,* c. 1956; Ink and Dr. Martin's aniline dye on Strathmore paper; 23 x 16¼ in.

113 (bottom) *"See a Shoe and Pick It Up and All Day Long You'll Have Good Luck"* (from: *A la Recherche du Shoe Perdu* by Andy Warhol, Shoe Poems by Ralph Pomeroy, 1955); Hand-colored offset lithograph on paper; 9¾ x 13¾ in.

114 (top and bottom) *"You Can Lead a Shoe to Water but You Can't Make It Drink"* (from: *A la Recherche du Shoe Perdu* by Andy Warhol, Shoe Poems by Ralph Pomeroy, 1955); Hand-colored offset lithograph on paper; 9¾ x 13¾ in.

115 (top) *"You Can Lead a Shoe to Water but You Can't Make It Drink"* (from: *A la Recherche du Shoe Perdu* by Andy Warhol, Shoe Poems by Ralph Pomeroy, 1955); Hand-colored offset lithograph on paper; 9¾ x 13¾ in.

115 (bottom) *"Sunset and Evening Shoe"* (from: *A la Recherche du Shoe Perdu* by Andy Warhol, Shoe Poems by Ralph Pomeroy, 1955); Offset lithograph and watercolor on paper; 9¾ x 13¾ in.

116 *Shoe and Leg,* c. 1956; Ink and Dr. Martin's aniline dye on Strathmore paper; 19½ x 13⅝ in.

117 *Leg and High Heel,* 1956; Silver leaf, ink, and Dr. Martin's aniline dye on white paper; 17⅞ x 12½ in.

118 (top and bottom) *"Anyone for Shoes?"* (from: *A la Recherche du Shoe Perdu* by Andy Warhol, Shoe Poems by Ralph Pomeroy, 1955); Hand-colored offset lithograph on paper; 9¾ x 13¾ in.

119 (top) *"Anyone for Shoes?"* (from: *A la Recherche du Shoe Perdu* by Andy Warhol, Shoe Poems by Ralph Pomeroy, 1955); Hand-colored offset lithograph on paper; 9¾ x 13¾ in.

119 (bottom) *High Heel,* c. 1956; Gold leaf, ink, Dr. Martin's aniline dye, and stamped gold on Strathmore paper; 14⅞ x 15¾ in.

120 (top) *"My Shoe Is Your Shoe"* (from: *A la Recherche du Shoe Perdu* by Andy Warhol, Shoe Poems by Ralph Pomeroy, 1955); Hand-colored offset lithograph on paper; 9¾ x 13¾ in.

120 (bottom) *Shoe Still-Life,* c. 1955; Ink and Dr. Martin's aniline dye; 14½ x 15 in.

121 (top and bottom) *"Uncle Sam Wants Shoe!"* (from: *A la Recherche du Shoe Perdu* by Andy Warhol, Shoe Poems by Ralph Pomeroy, 1955); Hand-colored offset lithograph on paper; 9¾ x 13¾ in.

122 (top and bottom) *"Dial M for Shoe"* (from: *A la Recherche du Shoe Perdu* by Andy Warhol, Shoe Poems by Ralph Pomeroy, 1955); Offset lithograph and watercolor on paper; 9¾ x 13¾ in.

123 (top) *"Dial M for Shoe"* (from: *A la Recherche du Shoe Perdu* by Andy Warhol, Shoe Poems by Ralph Pomeroy, 1955); Offset lithograph and watercolor on paper; 9¾ x 13¾ in.

123 (bottom) *"Shoe Bright, Shoe Light, First Shoe I've Seen Tonight"* (from: *A la Recherche du Shoe Perdu* by Andy Warhol, Shoe Poems by Ralph Pomeroy, 1955); Hand-colored offset lithograph on paper; 9¾ x 13¾ in.

124 (top and bottom) *"Shoe of the Evening, Beautiful Shoe"* (from: *A la Recherche du Shoe Perdu* by Andy Warhol, Shoe Poems by Ralph Pomeroy, 1955); Offset lithograph and watercolor on paper; 9¾ x 13¾ in.

125 (top and bottom) *"Shoe of the Evening, Beautiful Shoe"* (from: *A la Recherche du Shoe Perdu* by Andy Warhol, Shoe Poems by Ralph Pomeroy, 1955); Offset lithograph and watercolor on paper; 9¾ x 13¾ in.

126 *Female Fashion Figure,* c. 1960; Ink and Dr. Martin's aniline dye on board; 21⅞ x 16½ in.

128 *Hand Mirror with Rose,* c. 1957; Ink and tempera on Strathmore paper; 14½ x 11⅛ in.

129 *Female Fashion Figure,* c. 1959; Ink and Dr. Martin's aniline dye on Strathmore Seconds paper; 28⅝ x 22½ in.

130 *Female Fashion Figure,* c. 1959; Ink and Dr. Martin's aniline dye on Strathmore Seconds paper; 28⅝ x 22½ in.

131 *Three Fans and One Flower,* c. 1957; Ink and Dr. Martin's aniline dye on Strathmore paper; 14⅞ x 22⅞ in.

132 *Glove Holding Rose,* c. 1957; Ink on Strathmore paper; 14⅝ x 11¾ in.

133 *Female Head,* c. 1958; Ink and Dr. Martin's aniline dye on Strathmore paper; 23 x 12⅛ in.

134 *Female Head,* c. 1956–58; Ink and Dr. Martin's aniline dye on Strathmore paper; 22⅞ x 15⅝ in.

135 *Female Head with Stamp,* c. 1960; Ink and Dr. Martin's aniline dye on Strathmore paper; 23 x 14⅛ in.

136 *Female Head,* c. 1958; Ink and Dr. Martin's aniline dye on Strathmore paper; 19⅝ x 13 in.

137 *Female Head with Stamps,* c. 1959; Ink and Dr. Martin's aniline dye on Strathmore paper; 18⅞ x 11½ in.

138 *Female Head,* c. 1958; Ink and Dr. Martin's aniline dye on Strathmore paper; 23⅛ x 13⅛ in.

139 *Female Head,* c. 1958; Ink and Dr. Martin's aniline dye on Strathmore paper; 23 x 14½ in.

140 *Female Head,* c. 1958; Ink and Dr. Martin's aniline dye on Strathmore paper; 23 x 14 in.

141 *Female Head,* c. 1956–58; Ink and Dr. Martin's aniline dye on Strathmore paper; 22⅞ x 14½ in.

142 *Female Head,* c. 1956–58; Ink and Dr. Martin's aniline dye on Strathmore paper; 22⅞ x 14½ in.

143 *Female Head,* c. 1956–58; Ink and Dr. Martin's aniline dye on Strathmore paper; 23 x 14½ in.

144 *Female Head with Stamps,* c. 1959; Ink on Strathmore paper; 22⅝ x 14⅝ in.

145 *Female Head,* c. 1958; Ink and Dr. Martin's aniline dye on Strathmore Seconds paper; 22½ x 17½ in.

146 *Female Head Wearing Hat with Netting,* 1956; Ink and wash on Strathmore paper; 18½ x 10¾ in.

147 *Female Fashion Figure with Flowers and Plants,* c. 1960; Ink and Dr. Martin's aniline dye on Strathmore Seconds paper; 28½ x 19¼ in.

148 *Two Female Fashion Figures,* c. 1960; Ink and Dr. Martin's aniline dye on Strathmore paper; 29 x 23 in.

149 *Two Female Fashion Figures,* c. 1960; Ink and Dr. Martin's aniline dye on Strathmore paper; 29 x 23 in.

150 *Hat on Stand,* c. 1958; Ink on Strathmore paper; 11½ x 7⅛ in.

151 *Rose and Handkerchief,* c. 1958; Ink and tempera on Strathmore paper; 15¼ x 12 in.

152 *Female Head Wearing Hat,* c. 1958; Ink on Strathmore paper; 10⅜ x 6¼ in.

153 *Three Hats on Stand,* c. 1957; Ink on Strathmore paper; 14¼ x 11⅜ in.

154–155 *Eight Female Heads Wearing Sunglasses,* 1957; Ink and tempera on Strathmore paper with acetate overlay; 15¾ x 22½ in.

156 *Female Fashion Figure,* c. 1959; Ink and tempera on Strathmore paper; 13½ x 6⅞ in.

157 *Bra and Girdle,* c. 1958; Ink on Strathmore paper; 14¼ x 10⅛ in.

158 *Female Fashion Figure,* c. 1959; Ink and wash on Strathmore paper; 22⅝ x 14 in.

159 (top) *Shoe with Registration Marks,* c. 1958; Ink and tempera on Strathmore paper; 8½ x 12 in.

159 (bottom) *Shoe with Registration Marks,* 1955; Ink and tempera on Strathmore paper; 8 x 11 in.

160 (top) *Three Female Fashion Figures (Partial),* c. 1958; Ink and wash on Strathmore paper; 13¾ x 22⅞ in.

160 (bottom) *Shoe and Belt with Registration Marks,* c. 1955; Ink and tempera on Strathmore paper; 7¼ x 9 in.

161 *Female Fashion Figure (Back View),* c. 1960; Ink and Dr. Martin's aniline dye on Strathmore paper; 19¾ x 14½ in.

162 *Female Fashion Figure,* c. 1960; Ink and Dr. Martin's aniline dye on Strathmore paper; 22½ x 13⅜ in.

163 *Female Fashion Figure,* c. 1959; Ink and Dr. Martin's aniline dye on Strathmore paper; 20⅛ x 24¾ in.

164 *Female Head with Diamond Choker Necklace,* c. 1960; Ink and wash on Strathmore paper with acetate overlay; 14½ x 11⅝ in.

166 *Purse,* 1960; Ink and tempera on Strathmore paper with acetate overlay; 14¼ x 11 in.

167 *Necklace, Pins and Earrings,* c. 1960; Ink and tempera on Strathmore paper with tissue paper; 23 x 16⅛ in.

168 *Necklace,* c. 1958; Ink on Strathmore paper on board; 12¾ x 5½ in.

169 *Five Pins,* c. 1958; Ink and tempera on Strathmore paper; 22½ x 11 in.

170 (top left) *Pin,* stamped "Harper's Bazaar 8/19/55" on verso; Ink, graphite, and white paint on Strathmore paper; 11 x 8⅞ in.

170 (top right) *Pin,* stamped "Harper's Bazaar 8/19/55" on verso; Ink and graphite on Strathmore paper; 11½ x 6⅞ in.

170 (bottom left) *Pin,* stamped "Harper's Bazaar 8/19/55" on verso; Ink, graphite, and white paint on Strathmore paper; 10½ x 8¾ in.

170 (bottom right) *Pin,* c. 1955; Ink and graphite on Strathmore paper; 9 x 11⅜ in.

171 *Earring,* stamped "Mario 1956" on verso; Ink, graphite, and white paint on Strathmore paper; 7⅞ x 5⅝ in.

172 *Female Hand,* c. 1960; Ink on Strathmore paper; 15⅛ x 11¼ in.

173 (top) *Bracelet,* c. 1955; Ink, graphite, and white paint on Strathmore paper; 9⅞ x 9½ in.

173 (middle) *Bracelet and Charm,* c. 1957; Ink on Strathmore paper; 14½ x 11½ in.

173 (bottom) *Necklace with Tassels,* stamped "Harper's Bazaar 8/19/55" on verso; Ink, graphite, and white paint on Strathmore paper; 9½ x 11⅞ in.

174 (top left) *Ring,* stamped "Harper's Bazaar 8/19/55" on verso; Ink, graphite, and white paint on Strathmore paper; 8⅝ x 8⅜ in.

174 (top right) *Ring,* stamped "Harper's Bazaar 8/19/55" on verso; Ink and graphite on Strathmore paper; 5⅛ x 5 in.

174 (bottom left) *Ring,* stamped "Harper's Bazaar 8/19/55" on verso; Ink, graphite, and white paint on Strathmore paper; 8¼ x 9½ in.

174 (bottom right) *Ring,* stamped "Harper's Bazaar 8/19/55" on verso; Ink, graphite, and white paint on Strathmore paper; 9⅛ x 7¾ in.

175 (top left) *Leaf Pin,* stamped "Harper's Bazaar 8/19/55" on verso; Ink and graphite on Strathmore paper; 9⅝ x 12⅝ in.

175 (top right) *Earring,* stamped "*Harper's Bazaar* 8/19/55" on verso; Ink, graphite, and white paint on Strathmore paper; 9 x 7¼ in.

175 (bottom left) *Pin,* stamped "*Harper's Bazaar* 8/19/55" on verso; Ink, graphite, and white paint on Strathmore paper; 10¼ x 9⅜ in.

175 (bottom right) *Pin,* stamped "*Harper's Bazaar* 8/19/55" on verso; Ink, graphite, and white paint on Strathmore paper; 10⅝ x 10¼ in.

176 *Female Fashion Upper Torso,* c. 1958; Ink and wash on Strathmore paper; 19 x 14⅜ in.

177 *Necklaces and Pins,* c. 1959; Ink on Strathmore paper; 14 x 23 in.

178 *Two Necklaces,* c. 1955; Ink on Strathmore paper; 23 x 16 in.

179 *Necklace,* 1957; Ink and tempera on Strathmore paper; 18 x 12⅜ in.

180 *Necklace,* c. 1957; Ink on Strathmore paper; 12¾ x 9⅞ in.

181 *Shoe, Necklace and Collar with Registration Marks,* c. 1955; Ink and tempera on Strathmore paper; 8⅝ x 11¼ in.

182–183 *Multiple Fashion Accessories,* c. 1960; Ink and tempera on Strathmore paper; 13 x 23 in.

184 (top) *Shoe and Handbag,* c. 1856; Graphite on ivory paper; 24 x 18 in.

184 (bottom) *Shoe and Purse,* c. 1956; Ink and tempera on Strathmore paper; 9½ x 13¾ in.

185 *Shoe with Lower Legs and Umbrella,* c. 1960; Ink, wash, and tempera on Strathmore paper; 22½ x 15¼ in.

186 *Sneaker and Glove,* 1957; Ink on Strathmore paper; 12¼ x 8½ in.

187 *Multiple Clothing Accessories,* c. 1960; Ink and tempera on Strathmore paper; 16¼ x 9¼ in.

188 *Six Handbags,* c. 1958; Ink and tempera on Strathmore paper; 23 x 17 in.

189 *Multiple Clothing Accessories,* c. 1958; Ink and tempera on Strathmore paper; 20 x 14¼ in.

190 *Pair of Gloves,* c. 1958; Ink on Strathmore paper; 13¾ x 11⅛ in.

191 *Purse and Glove,* c. 1956; Ink and tempera on Strathmore paper; 14½ x 11½ in.

192 *Purse,* c. 1954; Ink and tempera on Strathmore paper; 11 x 9½ in.

193 *Six Handbags in a Frame,* c. 1958; Ink and tempera on Strathmore paper; 13⅜ x 13 in.

194 *Female Fashion Figure,* c. 1960; Ink and Dr. Martin's aniline dye on board; 22 x 17½ in.

195 (top) *Purse,* c. 1956; Ink and tempera on Strathmore paper; 9½ x 11 in.

195 (bottom) *Five Shoes on Shoe Stand,* 1961; Ink and wash on Strathmore paper; 12½ x 23 in.

196 *Legs and High Heels,* c. 1957; Gold leaf, ink, and stamped gold collage on Strathmore paper; 24⅝ x 19¼ in.

198–199 *Babs,* c. 1956; Ink, collage, and gold and silver leaf on paper; 12 x 16 in.

200 (top) *High Heel,* c. 1957; Gold leaf, ink, and stamped gold collage on Strathmore paper; 14½ x 23 in.

200 (bottom) *High Heel Shoe,* c. 1957; Gold leaf, ink, and stamped gold collage on Strathmore paper; 23 x 29 in.

201 *High Heel,* c. 1956; Gold leaf, ink, and stamped gold collage on Strathmore paper; 11¼ x 15 in.

202 *High Heel,* c. 1957; Gold leaf, ink, and stamped gold collage on Strathmore paper; 18¼ x 22⅝ in.

203 (top) *High Heel,* c. 1956; Gold leaf, ink, and stamped gold collage on Strathmore paper; 13⅛ x 13¼ in.

203 (bottom) *High Heel,* c. 1957; Gold leaf, ink, Dr. Martin's aniline dye, and stamped gold on Strathmore paper; 12⅞ x 15¾ in.

204 *Untitled (Shoe),* 1952; Gold leaf, ink, and collage on paper; 9⅞ x 13 in.

205 *"Wade" Shoe,* 1956; Gold leaf, ink, and stamped gold collage on Strathmore paper; 15⅛ x 11⅞ in.

206 *"To All My Friends" Shoes,* c. 1957; Gold leaf and ink on Strathmore paper; 9 x 8 in.

208 (top) *Man's Shoe,* c. 1956; Gold leaf, ink, and stamped gold collage on Strathmore paper; 23 x 29 in.

208 (bottom) *Man's Shoe,* c. 1957; Gold leaf, silver leaf, and ink on Strathmore paper; 14½ x 23 in.

209 *"Mr. Royak" Boot*, c. 1956; Gold leaf and ink on Strathmore paper; 18 x 12⅜ in.

210 *Seated Female Holding Mirror*, c. 1953; Ink on tan paper; 11⅞ x 8⅞ in.

211 *Standing Female with Camera*, c. 1953; Ink on tan paper; 11⅞ x 8⅞ in.

212 *Carol*, c. 1957; Gold leaf, ink, Dr. Martin's aniline dye, and ballpoint on Strathmore paper; 19 x 10 in.

213 *Reclining Female*, c. 1955; Gold leaf, ink, Dr. Martin's aniline dye, and graphite on Strathmore paper; 12½ x 23 in.

214 [left] *Tattooed Woman Holding Female Rose*, c. 1955; Offset lithograph on pale green onionskin paper; 29 x 11 in.

214 [right] *Costumed Female Figure*, c. 1955; Ink and Dr. Martin's aniline dye on Strathmore paper; 28⅝ x 22⅝ in.

215 Untitled ("Jean Pierre Gredy" Boot), c. 1956; Ink, gold leaf, and collage on Strathmore paper; 16⅛ x 9½ in.

216 *Unidentified Female*, c. 1957; Gold leaf, ballpoint, and Dr. Martin's aniline dyes on Manila paper; 16⅞ x 13¾ in.

217 *Female Head*, c. 1955; Ink on Strathmore paper; 13⅝ x 10⅝ in.

218 *Unidentified Female*, c. 1957; Gold leaf and ink on Strathmore paper; 23 x 14½ in.

219 *Unidentified Female*, 1957; Gold leaf and ink on Strathmore paper; 29 x 22⅞ in.

220 *Unidentified Female*, c. 1957; Gold leaf and ink on Strathmore paper; 23⅛ x 15½ in.

221 *Unidentified Female*, 1957; Silver leaf, ink, and Dr. Martin's aniline dye on paper; 25⅛ x 16⅜ in.

222 *Female Head with Partial Figure*, c. 1958; Ink, Dr. Martin's aniline dye, and collage on Strathmore paper; 22⅝ x 13¾ in.

223 *Female Head with Partial Figure*, c. 1958; Ink and Dr. Martin's aniline dye on Strathmore paper; 23 x 14½ in.

224 *Unidentified Female*, c. 1957; Silver leaf, ink, and Dr. Martin's aniline dye on Strathmore paper; 23⅛ x 28⅞ in.

226 *Female Head*, c. 1957; Ink on Strathmore paper; 15 x 23 in.

227 *Unidentified Female*, c. 1957; Silver leaf, ink, and tempera on Strathmore paper; 14½ x 14⅝ in.

228 *Female Faces*, c. 1960; Ink and gouache on Strathmore paper; 23⅛ x 13½ in.

229 *Female Head*, c. 1958; Ink and Dr. Martin's aniline dye on Strathmore paper; 23 x 14½ in.

230 *Female Head*, c. 1960; Ink and Dr. Martin's aniline dye on Strathmore Seconds paper; 28⅝ x 22⅝ in.

231 *Female Head*, c. 1960; Ink and Dr. Martin's aniline dye on Strathmore Seconds paper; 28⅝ x 22⅝ in.

232 *Unidentified Female*, c. 1960; Black ballpoint on manila paper; 16⅝ x 13⅞ in.

233 *Unidentified Female*, c. 1960; Black ballpoint on manila paper; 16⅝ x 13⅞ in.

234 *(Stamped) Lips*, c. 1959; Ink and Dr. Martin's aniline dye on Strathmore paper; 14½ x 11¼ in.

235 *Female Head*, 1960; Ink and Dr. Martin's aniline dye on Strathmore Seconds paper; 28⅝ x 22⅝ in.

236 *Female Head with Stamps*, c. 1959; Ink and Dr. Martin's aniline dye on Strathmore paper; 22⅝ x 14¼ in.

237 *Female Head*, c. 1960; Ink and Dr. Martin's aniline dye on Strathmore Seconds paper; 28⅝ x 22⅝ in.

238 *Female Head*, c. 1958; Ink and Dr. Martin's aniline dye on Strathmore Seconds paper; 28⅝ x 22⅝ in.

239 *Female Head with Stamps*, c. 1960; Ink and Dr. Martin's aniline dye on Strathmore paper; 22½ x 16¼ in.

240–241 *Three Female Figures and Fashion Accessories*, c. 1960; Ink and Dr. Martin's aniline dye on Strathmore paper on board; 18½ x 26 in.

242–243 *Fantasy Shoes*, c. 1956; Ink and Dr. Martin's aniline dye on Strathmore paper; 22⅝ x 28⅝ in.

244 Bonwit and Teller ad proof, c. 1955–59.

245 I. Miller advertisement, c. 1955–59.

246 Illustration for *The New York Times*, May 10, 1958.

247 I. Miller advertisement, *The New York Times*, September 25, 1955.

256 *Buttons*, c. 1959; Ink and Dr. Martin's aniline dye on Strathmore paper; 10⅛ x 9¼ in.

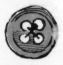
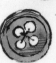
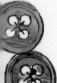

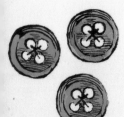
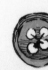

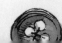